Revised Edition

Mostly Mittens

Ethnic Knitting Designs from Russia

Charlene Schurch

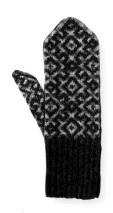

Martingale®
& C O M P A N Y

Mostly Mittens:
Ethnic Knitting Designs from Russia
Revised Edition
© 2009 by Charlene Schurch

Martingale®
& C O M P A N Y

Martingale & Company®
20205 144th Ave. NE
Woodinville, WA 98072-8478 USA
www.martingale-pub.com

Credits

President & CEO: Tom Wierzbicki
Editor in Chief: Mary V. Green
Managing Editor: Tina Cook
Developmental Editor: Karen Costello Soltys
Technical Editor: Ursula Reikes
Copy Editor: Marcy Heffernan
Design Director: Stan Green
Production Manager: Regina Girard
Illustrator: Robin Strobel
Cover & Text Designer: Adrienne Smitke
Photographer: Brent Kane

Printed in China
14 13 12 11 10 09 8 7 6 5 4 3 2 1

Library of Congress Cataloging-in-Publication Data
Library of Congress Control Number: 2009033339

ISBN: 978-1-56477-929-8

Mission Statement
Dedicated to providing quality products
and service to inspire creativity.

~~~~~~~~~~~~~~~~~~~~~~~~~~~

## Dedication

To Fred, who continues to encourage, listen, and create an exciting life that also includes my knitting.

~~~~~~~~~~~~~~~~~~~~~~~~~~~

Acknowledgments

Thank you:
To Anne Novotny Tompkins, my mother, who patiently taught me to knit (multiple times), who gave me an appreciation for things Eastern European, and who test-knitted some very early instructions.

To Beth Parrott, good friend and extraordinary knitter, for help with knitting a few mittens and insight into the relationship between mitten and cap sizes.

To Sergei Bunaev and Mark Havill, for sensitive translation.

To Al Bersbach, for his generosity in sharing his adventure in the Komi Republic on his website and for lending me his Komi mittens and socks.

To Rob Pulleyn, my first publisher of this work, for his vision and his enthusiasm.

To Mary Green and Karen Soltys, for their continued support for my work and for their generosity in adding to the knitting literature.

Contents

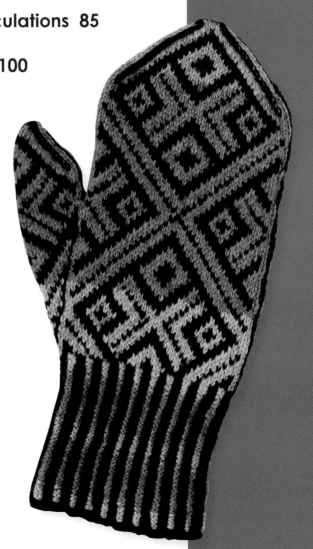

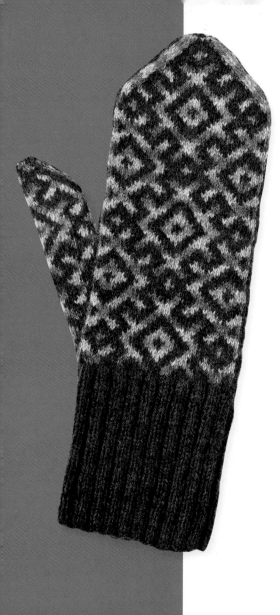

Introduction

It is thanks to Martingale & Company that this reprint is available. Fundamentally this is the same book that was published in 1998. A few minor technical items have been corrected, a few mittens have been reknit, and two new cap patterns are included, as well as some general information about adapting the mitten patterns in this book to knit a cap.

In presenting the knitting patterns of the Komi people, I have tried to preserve a small portion of the world's knitting traditions that otherwise might become lost. As you knit these logical and sophisticated patterns, consider that they have been passed down through the generations in an oral and visual, rather than written, tradition. In working through the projects, I hope that you will experience the thrill of exploring older knitting traditions. By placing them in context, I hope that they will speak to you from the past, as they did to me, through the language of our stitches.

Reading Richard Rutt's *A History of Hand Knitting* (see "Bibliography" on page 112) made a deep impression on me. Previously I hadn't really given much thought to knitting traditions other than those that produce the beautiful, perennially fashionable Scandinavian sweaters. After reading Rutt's book, I found knitting could be of academic interest as well. Since I love to knit, the thought that I could research, share, and thus preserve traditions for other knitters to enjoy appealed to me; it was a way that I could touch the past and affect the future. I was captivated by the idea and became inspired to do my own research. But where to begin? Being of Czech heritage, I searched Rutt's index and reviewed the book for related references. During this investigation, I found there was a gap in the knitting literature of the Slavic people (Czechs, Poles, Bulgarians, Yugoslavians, and Russians), save for lace shawls. I knew these people must have knit because of Eastern Europe's severe winters and the presence of sheep. My search was on.

Discovering the Komi

At the New York Public Library, I found two intriguing little volumes by Galina Nikolaevna Klimova about the textile traditions of the Komi, whose homeland is in northeast European Russia, just west of the Ural Mountains and close to the Arctic Circle. *Uzornoe Viazanie Komi* is a study of Komi knitting, and *Komi Textile Ornamentation*, published later, looks at the development of Komi textile ornamentation from a genealogical point of view as it is applied to Komi knitting, weaving, and embroidery. The pictures of the mittens and stockings were very different from what I had seen before, but they were reminiscent of some of those found in Lizabeth Upitis's book of Latvian mittens (see "Bibliography" on page 112). The style wasn't Czech, but at that point at least, I thought it was Slavic. As I later learned, the Komi are related to the Finns and Estonians.

I found the pictures compelling enough to have Klimova's texts translated. I was fortunate enough to have Sergei Bunaev, a native Siberian (Buryiat) and member of the Russian department at Wesleyan University, help me. In addition to translating the text, he was able to place the Komi in a cultural and human context that caught my imagination. I wanted to know more and was off to any library I could find for background information. Since the Komi are a Russian ethnic minority and didn't figure in any of the major political events of Russian history, the card catalog yielded precious little. What I did learn about the Komi of today was the age-old story of assimilation and change that has affected similar groups of native people around the world. At the turn of the twentieth century, native Russians began migrating north. Shortly thereafter, the homeland of the Komi was found to have rich reserves of oil and natural gas. This discovery brought an even greater influx of workers, who gradually overshadowed the older Komi culture and traditions with their own. Faced with this information, I realized how vital it was to help preserve what I could.

The search for printed information was somewhat of an adventure. There were some sociological papers written about the Komi from the University of Indiana; these were in the Library of Congress. They provided some insight into how the Komi lived and raised reindeer. I also found two little volumes of gentlemen's adventuring magazines from the early 1900s. This was during the time when expeditions were mounted to the North and South Poles. Not all of them went that far away, and lucky for me I found some accounts of trips to the Komi Republic. I searched through the *National Geographic* magazine index. It's my guess that during the time of the Soviet Union there wasn't much in the way of visiting photographic expeditions, so I found nothing there. Most of what I did find below was from the *Gentleman's Journal* and translation from Klimova.

The Komi People

The Komi people are of the Finno-Ugric language group. This group is relatively small today, with roughly 22.5 million people speaking one of its languages; the Hungarians, with 14 million people, are the largest representation, followed by the Finns at 5 million, and the Estonians at 1 million. All of the Finno-Ugric people were originally from Central Asia in the Ob River Basin and migrated at various times from before 400 AD to sometime in the Middle Ages.

The Komi were in Russia by 1000 to 1200 AD. Originally a migratory, reindeer-herding people, they began establishing a livelihood dependent on farming, fishing, and hunting reindeer around 1700. As late as the mid-1950s, the Komi were still living in village-type communities. Today there are only about 285,000 Komi speakers. Russia considers the Komi one of the 26 recognized ethnic minorities and they form an independent republic.

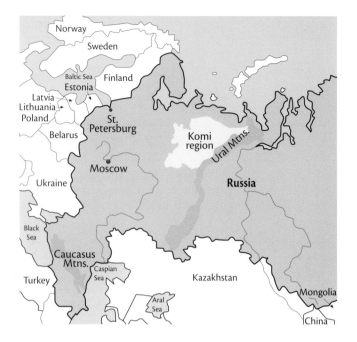

Komi Knitting

With a basic understanding of the traditional Komi culture and lifestyle, I was able to turn to Klimova's books. Her text deals mostly with patterns, rather than the specific construction techniques. What she does offer about construction is based on simple observation: the stockings were knit with patterning on the leg, but the feet were knit in one color; the same patterns were used for both men and women. Mittens and stockings with more complex patterns were originally made for festive occasions, and then as they aged they were worn for everyday. Klimova notes that the simpler patterns were knit by women who could not handle the more complicated ones—just as today, some people are more capable than others. It was refreshing to read and consider that not every nineteenth-century knitter was doing museum-quality work.

The fundamental design element of the Komi patterns is the diamond. Klimova takes the search for the genesis of this back to the second century BC. Pottery pieces with diamond patterns from that period have been found in areas of what is today Kazakhstan, the southern Urals, and southern Siberia. Scholars believe these diamond-based patterns were first used in "soft" materials, such as in weaving and embroidery, before they were used for decorating ceramics.

Klimova found that by the 1970s, when she was researching Komi textiles, only the older women were knitting, and it was not to the beautiful standard of long ago. It was her quest to preserve this heritage as well.

Komi Dress

The Komi, like many ethnic groups, began to abandon their traditional dress in favor of other styles as they became assimilated into a larger Russian culture. Before that time, women were responsible for making all of the clothing for their families. They had to rely on their crops and animals to provide the raw materials for their garments. Traditionally, the Komi would wear a tunic made from reindeer skin. In the winter, linen undershirts were worn under the reindeer skin. A seventeenth-century visitor to the area noted that the men and women dressed alike; even the patterns on the mittens and stockings were identical.

Women would spin flax, hemp, and wool from plants and animals that they raised themselves. The men were responsible for carving the spindles out of wood. Vegetable and mineral dyes were used until the mid-nineteenth century when chemical dyes became available. Knitting needles were originally made of wood or bone. When steel needles became available, the Komi would purchase or trade for them with goods they produced.

Before they could marry, girls were expected to weave at least two dozen towels and 100 yards of cloth, as well as make three dozen pairs of stockings, the same amount of mittens, and one or two dozen shirts. The quantity and quality of work became the bride's recommendation. In order to fill this order, girls began this preparation at the age of 10. All the goods were then presented to the family and relatives of the bridegroom at the wedding.

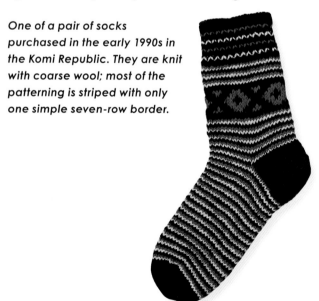

One of a pair of socks purchased in the early 1990s in the Komi Republic. They are knit with coarse wool; most of the patterning is striped with only one simple seven-row border.

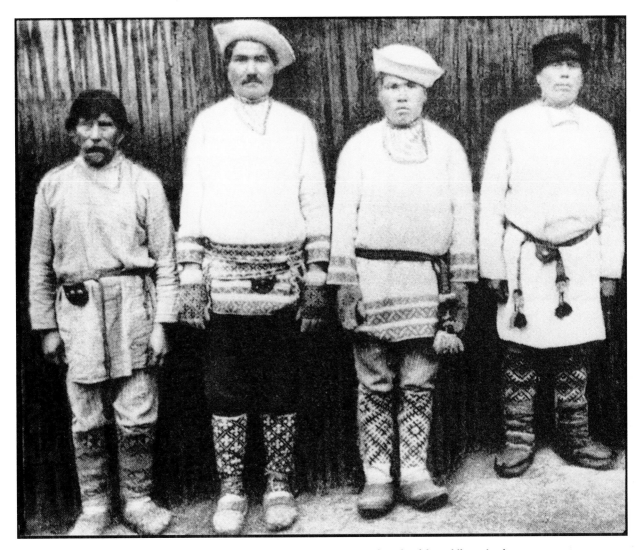

Komi men wearing patterned-knit hose as well as woven belts and embroidered linen tunics.

The Komi Influence

As with any research, unanticipated connections often surface. Without seeking it out, I found an interesting link that shows how knitting traditions pass from one culture to another and how they can influence and affect generations of knitters around the world. Eve Harlow, in *The Art of Knitting* (see "Bibliography" on page 112), reports that two-color knitting fragments from the sixteenth century were found in Latvia, the Komi Republic, the Karelian district of Russia, Estonia, and the Caucasus. Alice Starmore, in her *Book of Fair Isle Knitting* (see "Bibliography" on page 112), traces the importation of colored knit pieces from Estonia or Finland and asserts this was the event that began the

beautiful Fair Isle tradition in Scotland. The languages spoken by the people living in the areas mentioned by both Harlow and Starmore are Finno-Ugric. In researching Komi traditions, I have found that all of the Finno-Ugric textile work shares a similarity of ornamentation; photographs of their textile work show that the complex diagonal geometric pattern is clearly part of their culture. Now as I look at the sophisticated Fair Isle pieces, I can clearly see the influence of the older Finno-Ugric traditions. For me, it was one more example of how the common language of our stitches extends beyond the boundaries of time, cultural differences, and geography.

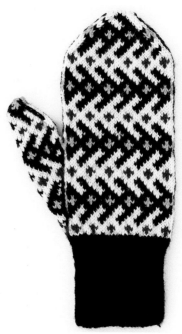

Komi Patterns

The Komi, as preliterate people, held their patterns in their memory and in their knitting. Therefore, most of the patterns that evolved did so around a system that made remembering them easier. Every Komi village had its own distinct variations of the basic patterning, and a person who knew the patterns could tell where another person was from by looking at their knitted garments. All of the Komi knitted goods of the late nineteenth and early twentieth centuries were knit with at least two colors. Stripes were used on the cuffs of mittens and on the legs of stockings, providing a logical and easy way to introduce multiple colors—perfect for beginning knitters.

While knitting the design with two strands (or more) of colored yarn was a more complicated process, it created a beautifully patterned piece and a warmer garment. The yarn that's not being knit is carried along the back, creating "floats," which make an extra layer that traps warm air. For the Komi, any additional warmth must have been a welcome necessity during their long and brutal winters.

Combining Patterns

The appeal of Komi patterning is its simple symmetry. By using stripes, borders, and allover designs (called reticulations) of complex diagonal geometric patterning, the Komi developed a palette of pattern choices. They created their beautiful knit stockings and mittens by combining the patterns in attractive and imaginative ways. Add the dimension of color, and the possibilities seem almost endless. The basic motifs used in Komi knitting are different from the bulk of the patterning. These basic patterns are four stitches wide and are simple to look at and to visually understand. The larger patterns have a different structure. They are broadly geometric and have strong diagonal lines. These "lines" in the patterns tend to be three stitches wide. Some of the more intricate patterns use the basic structure of an original pattern, but, for instance, a light line is included in a dark line. A good example is the motif on the cuff of Mitten 15, which looks like it was edited to create the main motif in Mitten 31. At first glance, patterns constructed this way may look complicated. As you look closer, you'll begin to see how a few stitches, stacked row upon row, create a clever pattern that's easy to knit.

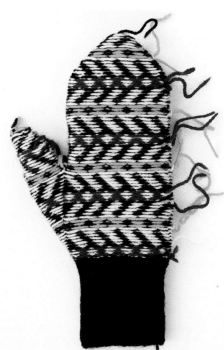

By turning a mitten inside out, you can see the floats that create an extra layer for warmth.

Most of the borders and reticulations that the Komi use are created upon a system where all the lines of the pattern are three stitches wide, and the pattern of the foreground and background are balanced (as much dark as light). The patterns can range in complexity from repeats of 6 to 72 stitches. These patterns are profound in their creation, since they look more complicated than they are, yet they're simple to hold in memory.

Reticulations are created with the principle of a background cross made of five stitches (three wide and three high). This results in every third row being worked as three dark and three light stitches, known as three-by-three patterns. The other rows are worked in one, three, or five stitches before changing color. These are easy to knit and make a nice tight fabric with relatively short floats on the back.

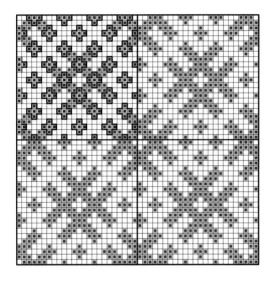

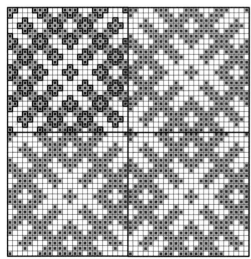

As you can see, the patterns are created from a grid of crosses in a repeat of 6 stitches by 6 rounds.

The diagonal-appearing pattern is aligned on the vertical and horizontal axis. Sometimes a portion of an allover design is selected for use as a border. A favorite pattern is a seven-row or "septenary" border. These are similar in construction to the reticulation but only have one axis. Over time there seems to have been some editing of the patterns. There are a few septenary borders that have some vertical lines, rather than being created like the reticulations. In addition, some of the wide borders and reticulations have had their pattern lines extended to five or seven stitches wide (as shown on Mittens 31 and 33). While still maintaining the diagonal geometric design of the original pattern, they look more airy than the denser, traditional patterns.

The star or snowflake pattern, very popular among the knitters of northern Europe, was introduced to the Komi by Russian migration in the late nineteenth century (see Mitten 30, page 88). The one used in Komi knitting is similar to the one used in Norwegian knitting, yet the Komi pattern retains its own variations.

As you look at the patterns and work with them, you'll begin to see their possibilities. The amount of the pattern you use affects the final design. Many of the septenary border patterns are taken from larger reticulations and wide borders, while wide borders can be expanded to create reticulations.

Working with the Projects

This book contains charts and instructions for 35 mittens. I've also included instructions for four caps along with generic instructions for knitting a cap using any of the mitten patterns. The instructions for the caps follow the mitten projects.

I've arranged the mittens in chapters according to their pattern system. Each chapter progresses from the easiest to the most complex. At the beginning of each chapter, you'll find detailed explanations of the pattern system with the mitten projects following. If you're a novice knitter, you may want to start with one of the projects from the Basic Patterns (pages 21–28), until you feel comfortable enough to work the more complex ones. Fundamentally, the only difference between knitting a basic pattern and a more complex one is attention to detail.

Sometimes the best way to decipher patterns is to work a few quick samples. Once you begin to translate the charts into stitches, your hands will take over, helping you understand where words often fail. As you knit, you'll begin to experience the beauty and logic of the Komi system as you watch the pattern unfold.

Positioning the Patterns for Designing Mittens and Caps

With their strong geometric lines, balanced light and dark coloration, and large repeats, Komi patterns require some thought when positioning them on small items. Graph paper or a good charting program on the computer is a great help, if not a necessity.

There are two basic rules for positioning the patterns:

1. Center the pattern. Match the focal point of the pattern with the focal point of the garment. Be aware that since you are centering the design, you will often need to start knitting somewhere other than at the beginning of the pattern, such as at a side seam.
2. Since Komi patterns all have an even number of stitches, place them on a visual ground with an odd number, so the central stitch is in the middle and the edges are the same. Not only is this more attractive, you'll find it's much easier to keep track of your pattern as you knit in the round.

When positioning a pattern for a mitten, start by creating a full chart of the whole hand. Center the pattern on the hand so the pattern at the tip of the mitten ends either in a complete repeat or at an attractive point in the pattern. Always begin at the tip since a partial pattern at the cuff is easier to overlook than an incomplete pattern at the tip. Then, fill in the pattern for the rest of the mitten. The chart at right is taken from Mitten 15. It illustrates pattern placement for creating an effective design.

There are several ways to position the design on the thumb. You can use a separate pattern altogether, as for Mitten 26. Or, you can copy the center of the mitten pattern onto the thumb chart. To do this, first take a look at the pattern and decide if you like it. You may want to move the pattern over by half a pattern, as for Mitten 30, so the whole star is on the thumb instead of half the star on each side with a center design.

Caps present a fun opportunity to use color and pattern. However, the shaping of a cap can be a bit of a problem when considering where to position the pattern. An easy way is to use one of the border patterns, placing it at the cuff. Then use a smaller pattern or a series of narrow borders as you work toward the top of the cap.

When selecting a mitten chart to use for a cap, keep in mind that you need to cast on five times the number of stitches in a hand chart. Refer to the "Sizes" in the individual caps to see the number of cast-on stitches for a particular size and gauge.

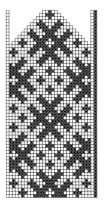

1. Design for mitten 15.

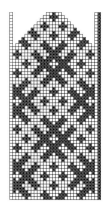

2. Works well, but not as strong as 1.

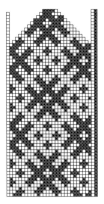

3. Pattern is off-center.

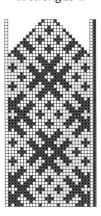

4. Weak lines at top.

Using the Patterns for Designing a Sweater

Although I haven't included sweater instructions in this book, more experienced knitters may want to expand some of the patterns to make larger garments. As you begin creating your design, follow the two rules for positioning a pattern on an item as you would for a mitten. Remember that the focal points for a sweater will be the shoulders. Make sure that you center your pattern, both on the front and back, so it will be complete or will end in a logical place. This means that you need to calculate an accurate gauge swatch to know how many rows you'll have between waistband and shoulder, and then adjust accordingly.

Since these are large patterns, you can use seam stitches, like those created for the mittens and caps (see page 15), or a vertical septenary border to provide a visual break when dividing the front and back. Alice Starmore offers a detailed discussion of designing patterned sweaters in her *Book of Fair Isle Knitting* and her *Charts for Colour Knitting* (see "Bibliography" on page 112).

In Praise of Mittens

- Mittens are knitting in its highest form; you create the fabric and shape it at the same time.
- They're small—materials aren't costly.
- They're extremely portable—you can work on them anywhere.
- You can complete a project quickly.
- Though small, they are a most generous gift.
- You can try new patterns and colors, gaining confidence before tackling a much larger project.
- They're an opportunity to display your talent all winter long.
- When you give hand-knit mittens to family and friends, you're also showing them your concern for their comfort in a beautiful way.
- They're fun to wear, whether you're making a snowman, shoveling snow, or walking the dog.
- You can wear the same pair of mittens every day, and unlike a shirt, no one will ever accuse you of not changing your clothes.

Basic Guidelines

Before you begin, read through the following guidelines to ensure a successful knitting experience.

Yarn

The needle size and gauge on yarn labels are typically for a sweater or garment that needs some drape to the fabric. For mittens, caps, and socks, I prefer to knit a much denser fabric. This has several advantages: it is more windproof; it will wear longer; and, depending on the yarn, it will shrink less. Knitting the mittens in fine yarn at a tight gauge shows the lovely Komi patterns to their best advantage, since knitting with bulky yarn and large needles would only show a small portion of the pattern. I've also found that working with two or more colors knit at many stitches to the inch creates a wonderfully rich-looking fabric. The yarns used in this book are labeled Sport and Fingering weight and are all 100% wool. It is my strong opinion that natural animal fibers such as wool, alpaca, llama, cashmere, and silk are the superior choice for mittens, since they offer better insulation than man-made yarns. If you like to wash mittens often, or you're knitting mittens as a gift for someone who likes to wash everything in the washing machine, I suggest you substitute sock or super-wash wool yarns.

The mitten instructions are "as knit," giving specific yarn and needle sizes. If these yarns are not available to you, there are many other wonderful yarns that you can successfully substitute. Keep in mind when substituting yarns that you must keep the same approximate weight-to-length ratio (grams/ounces to yards, or grams to meters). For best results, read your labels, compare the ratios, and substitute as closely as possible.

Needles

Double-pointed needles are a necessity for knitting a seamless pair of mittens. I use the 7" needles. The finger-sized 4" needles are big enough for a child's mitten and are somewhat easier to manage. You may need to give your hands time to adjust to using double-pointed needles, particularly in a smaller needle size. Just be patient.

Some knitters prefer using the 11" circular needles for socks and mittens. This is a matter of choice. I'm uncomfortable using circular needles, since the mittens

I've knit are too small around for that style of needle. However, I've included instructions for knitting with two circular needles on page 100.

We all have a preference for needle material; you can find them in metal, wood, bamboo, and plastic. If you are not enjoying the knitting, try another material and see if your hands like it better when knitting a very tight gauge. Be careful when using the smaller sizes of wooden needles; they may break if you hold them too tightly. Always look for double-pointed needles with sharp points rather than rounded points, since this makes decreasing easier.

The instructions for the mittens are written for using five needles (four holding the work and one to knit). By distributing the stitches evenly on four needles rather than three, the front and back are kept separate, and it is easier to know exactly where you are in the chart and on the mitten. Needles 1 and 2 hold the back stitches and needles 3 and 4 hold the palm stitches. When working with the charts, I draw a red line at the middle of the chart so that I start knitting on needles 1 and 3 at the right-hand side of the chart and needles 2 and 4 at the middle of the chart.

Gauge Swatches

When working in the round, you must knit the gauge swatch in the round. Many knitters (me included) have a different gauge—with the same yarn and needle size—when they knit in the round than when they knit flat. A good gauge swatch is at least 4" x 4". You can knit 4" in length, take it off the needles, and then cut to measure it flat. Or, you can knit 8" around and lay it flat to measure. I find I get a more accurate gauge measurement by counting whole stitches and dividing by inches.

While knitting a swatch takes time, making gauge adjustments before beginning a project will save you problems later on. You may need to adjust your needle size if your swatch doesn't match the gauge. If the swatch is larger than the gauge, try using a smaller needle size; if the swatch is smaller, try larger needles. You may think a half-stitch variance in gauge, either plus or minus, won't make much of a difference in the finished item. However, it can create a mitten that is either larger and longer, or smaller and shorter than you want.

Sizing

The mitten projects are written either in child or adult sizes medium and large, with the child's size large equivalent to an adult's size small. Since mittens need to fit the hand comfortably with a little room to spare, take accurate measurements for a correct fit. Measure around the knuckles, and then add 1" to provide extra room for the hand and the floats on the inside. Remember—it's the trapped air that makes a mitten warm. If you're undecided as to which size to knit, you'll be more satisfied choosing the larger one. As you can see from the chart, hand circumference and length are the same in classic mitten sizing.

Size	Circumference	Length
Child's medium	6"	6"
Child's large/ Adult's small	7"	7"
Adult's medium	8"	8"
Adult's large	9"	9"

Knitting with Two Colors

It's my opinion that right-handed or left-handed knitting should be added to the list of topics, such as religion and politics, that can't be argued successfully. It seems that every knitter will defend the method with which they're most familiar. Whether knitting right- or left-handed, there are three ways to hold the yarn while knitting with two colors: both colors in the left hand, both colors in the right hand, or one color in each hand as shown below. It is impossible to determine the style of knitting once the mitten is complete.

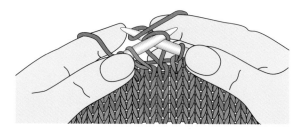

Holding one color of yarn in each hand

As part of full disclosure, I should state that when knitting with one color, I knit with the yarn in my left hand. Note that whichever method you use, be consistent throughout the knitting of a pair of mittens. The yarn that's held above the other will be the one to stand out in the pattern. Decide which color will be which in the beginning and hold the yarns consistently throughout, so the pattern will read the same all the way through the mitten.

Casting On and Beginning to Knit

I prefer the long-tail cast on since it produces a firm yet elastic edge. Make a slipknot at a distance from the end of the yarn approximately four times the length needed for the stitches you'll cast on.

Hold the needle in your right hand with the tail hanging forward and the ball end behind. Insert your left thumb and index finger between the two strands, spread them apart, and grab the strands with the last three fingers of your left hand, spreading them apart slightly. Think of the loop on the thumb as a stitch on the left-hand needle and the yarn around the index finger as the yarn on a continental knitter's left finger when knitting.

Bring the needles under the front strand of the thumb loop, then up and over the front strand of the index-finger loop. Catch the yarn, bringing it under the front of the thumb loop, using it to adjust tension on the new stitch as shown.

Distribute the stitches onto either three or four double-pointed needles, and then join them in the round. Be careful not to twist the stitches, making sure that the cast-on edge lies below the needles all the way around.

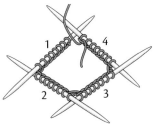

When working the ribbing, begin each needle with a knit stitch. Pick up the empty needle with your right hand and begin to knit. After knitting the first stitch, draw the running thread tightly to close the circle.

When you have finished knitting the stitches on the first needle, transfer the empty needle from your left to right hand and begin working on the second needle. I find the placement of the needles as shown above, to be comfortable while knitting by preventing the other needles from getting in the way. I work with needle 1, and the end is on top of needle 2, the working needle in my right hand is under needle 4; this is what works and feels right for me. If it feels clumsy for you, try changing one needle at a time to see if your comfort with needle position improves. Remember to keep the tension of the running thread between the stitches the same as at the junction of two needles; this will prevent a "ladder" effect of loose stitches.

Knitted-On Cast On

This cast on is used in the Komi Earflap Cap on page 108.

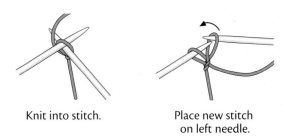

Knit into stitch. Place new stitch on left needle.

Cuffs

There are several cuff designs that are attractive and work well with the mitten designs in this book: plain ribbing, corrugated ribbing, and patterned two-color knitting.

Plain Ribbing

K2, P2 ribbing is my favorite cuff, and it's the simplest. It's highly elastic and grabs the wrist snugly. Using the long-tail cast on and specified yarn, cast on the number of required stitches in the pattern. Work in K2, P2 ribbing until desired length.

Corrugated Ribbing

Corrugated ribbing, where the knit stitches and purl stitches are worked in different colors, is more decorative and colorful than plain ribbing, but less elastic than single-color ribbing. You can introduce other colors by changing the colors of the knit or purl stitches. Follow these instructions for corrugated ribbing: Using the long-tail cast on and main color (MC) yarn, cast on the number of required stitches in the pattern.

Round 1: * K2 MC, K2 CC * repeat around. (Knitting all stitches on the first round avoids the purl bump).

Round 2: * K2 MC, P2 CC * repeat around. While working this ribbing, be sure to keep both working yarns in back of the work.

Keeping in the color pattern, knit the knit stitches and purl the purl stitches as they face you. Work round 2 until ribbing is desired length.

Patterned Two-Color Cuffs

Patterned cuffs in this book use the Komi patterns. The cast on is the Scandinavian twisted edge with two colors. The length of the patterning is about the same length as a ribbed cuff with an added ¾" band of single-color ribbing between the cuff and the mitten body, providing a snugger fit that keeps the wrist warmer.

To cast on for the Scandinavian twisted edge, begin with the long-tail cast on over one needle using two colors, holding one color over the thumb and the other over the index finger. Make two slipknots; do not count them as stitches. You'll slip them off before you begin to knit.

Round 1: * K1 MC, K1 CC * repeat around.

Round 2: Bringing both colors to the front of the work, * P1 MC, P1 CC * repeat around. After each stitch is worked, place the yarn to the left; bring the other on top and work.

Round 3: * P1 MC, P1 CC * repeat around. After each stitch is worked, place the yarn to the right; bring the other yarn from the bottom and work.

After working round 2, the yarns will be twisted and difficult to work. The twist created in round 3 is in the opposite direction and will untwist the yarns from round 2, making you ready to begin the pattern.

Increasing

An attractive thumb gore needs an increase that is unobtrusive and has a mirror image. There were several styles of increases that I tried before settling on Elizabeth Zimmermann's M1 (make 1) and M1R (make 1 reverse). It is just about the same structurally as the M1 that most people make using the running thread between two stitches. However, since the mittens are being knit at a very tight gauge, and using the running thread makes the fabric wrinkle, sometimes it's hard to find the proper color with the stranding on the inside of the mitten.

To make the M1 and M1R, begin with a backward loop over the needle, knit one and make a loop in the reverse way over the needle, as shown.

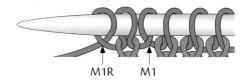

Place a marker. As you work in the round after the M1, work the first increase stitch in the standard manner; then knit the second increase stitch (M1R) through the back of the loop to tighten the stitch and make it flatter.

Duplicate Stitch

Use this technique to add stitches to some of the rows in Mitten 17, rather than carrying the color across a long span while knitting.

Tools

In addition to yarn and needles, you will need a tapestry needle, a pair of scissors, and a small crochet hook to pick up the three stitches that complete the thumb. I've also found using a magnetic board with a magnetic ruler to be very helpful. I put the chart on the board, placing the ruler just above the row I'm working. This lets me see what I've completed and where I am without the temptation to inadvertently knit ahead. These boards and rulers are available at knitting and craft stores.

General Mitten Instructions

Since the Komi used their patterns on mittens and stockings, they were knit in the round as multiples of the total number of stitches in the knitted article. For example, a mitten knit with 72 stitches around could have a 36-stitch pattern repeat. However, using this repeat limits you to 36, 72, 108, or 144 stitches. I've found it's very hard to get two sizes of adult mittens in that range. When designing the mittens within these boundaries, it was often necessary to use partial repeats.

To work with this, I used three stitches as "seam" stitches in a contrast color (CC), main color (MC), and contrast color (CC). These can also be called delineator stitches, since they create a boundary between the patterns on the front and back. Without this device, it would be difficult to create multiple sizes while showing the patterning to its best advantage.

The seam stitches serve several other purposes. They anchor both working colors to prevent a float that is too long, as would happen if the patterns were just cut off at the seam. They also help maintain the proper length of floats for decreasing at the tip. And the stitches help you avoid the "jog" in pattern that happens when knitting patterns in the round as you move from the end of one round to the beginning of the next. The seam stitches give the eye a resting place so the lack of match is not visually jarring.

I've made the mittens with a gored thumb. This seems to work perfectly with the seam stitches, which not only provide boundaries for the gore but also add a handsome design element. I've also incorporated seam stitches in three of the cap patterns beginning on page 101.

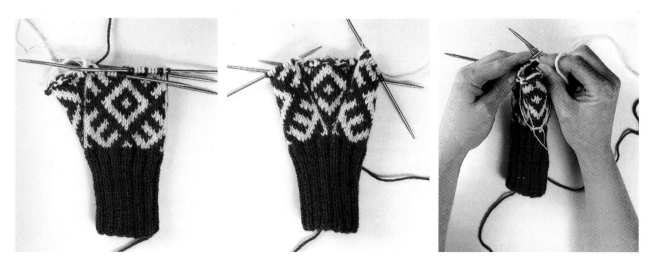

The thumb gore grows from the center seam stitch on the left of the chart. The boundary stitches create an attractive design. Once you get to the "crotch" of the thumb, slip the stitches on a holder; then complete the body of the mitten.

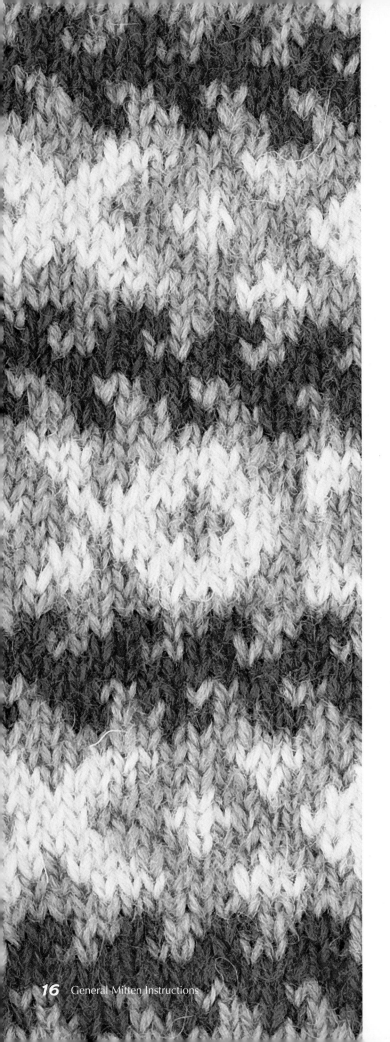

How to Use the Charts

The following chart shows two hand charts and one thumb chart to help illustrate how the charts work. The actual mitten charts in the book include one hand chart and two different-sized thumb charts. As you look at the chart and read these instructions, assume that the hand chart on the right is the back of the right mitten, and the hand chart on the left is the palm of the right mitten. Starting at the bottom-right side of the chart, you will work the back of the hand, then the thumb, and then the palm. The colored symbols in the chart below are visual cues to working the charts. Note that the actual mitten charts do not include these symbols. Follow the color key to knit the mitten.

The red line on the hand chart represents the pattern chart for the smaller size.

There are three seam stitches on the hand chart: the first two stitches and last stitch. For both sizes, work the first two seam stitches on the pinky side of the hand, then work the pattern for your size (within red lines for smaller size), and end with the last seam stitch. Work the thumb chart; note that the first stitch in the thumb chart replaces the first seam stitch on the hand chart. When knitting the second side (or palm) of the hand, for both sizes, skip the first seam stitch on the hand chart and start with the second seam stitch; work the pattern for your size and end with the last seam stitch on the hand chart.

- 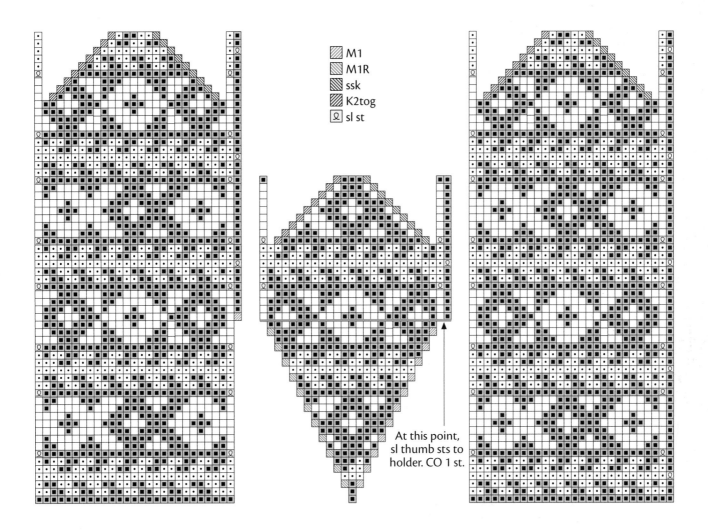 Use M1 to increase on right edge of thumb chart.

- Use M1R to increase on left edge of thumb chart.

- Use ssk for decreases on right edge of hand chart.

- Use K2tog for decreases on left edge of hand chart.

- When a round is worked with only one color, and one of the seam stitches is a contrasting color, slip the stitch of the contrasting color.

- When the thumb gore is complete, on the next round slip the thumb stitches to a length of thread or yarn. Use the make 1 stitch to replace the one seam stitch taken up by the thumb gore. From now on you'll work the hand chart twice (back of hand, then palm of hand), including the first two seam stitches and last seam stitch.

- Right and left mittens are identical and all references are to the right mitten—apologies to all left-handed knitters.

☑ M1
☒ M1R
☒ ssk
☑ K2tog
☒ sl st

At this point, sl thumb sts to holder. CO 1 st.

Individual Pattern Instructions

Information for each individual mitten pattern will give you the yarn, gauge, and needles to use. The pattern also states what cuff style and length to knit, as well as the size of the reticulation repeat (if applicable). After working the cuff, you'll follow the chart to work the remainder of the mitten.

The following example explains the basic procedure for knitting a mitten. Sizes given are for a child's size medium (large); an adult's size medium (large) in 8 sts=1"; and an adult's size medium (large) in 10 sts=1". The given numbers correspond to this sequence. While these instructions are not written out for each mitten pattern in the book, reading through them here will give you a feel for how to work each of the patterns simply by following the chart.

Cuff

CO 48 (56, 64, 72, 80, 92) sts. Work cuff as indicated in pattern for 3 (3¾, 3½, 3½, 3¾, 3¾)". If you have been knitting the cuff on three needles, rearrange the stitches on four needles for knitting the body; it's easier to keep your place on the chart when the stitches are divided this way.

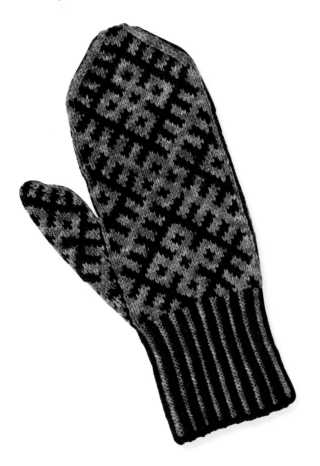

Hand and Thumb Gore

Work the body of the mitten in two-colored knitting in stockinette stitch. (When knitting in the round, stockinette stitch is made by knitting all rounds; there is no purling.) Remember, if making the smaller size, work seam stitches as indicated and follow chart within the red lines.

Rounds 1 and 2: Knit, following charted pattern. Work the hand chart to the first thumb stitch, work the first thumb stitch, then for the palm or second side of the hand, skip the first seam stitch of the hand chart and work to the end.

Round 3: K24 (28, 32, 36, 40, 46) stitches in pattern; start the thumb increase on the third needle with M1, K1, M1R. Remember, the thumb chart replaces the first seam stitch at the right side of the hand chart. When starting the palm or second side of the mitten, be sure to work only the second seam stitch of the hand chart, and finish the chart.

Thumb increases: For now, all the thumb stitches are on the third needle. When you have 11 thumb stitches, transfer 5 of them to the second needle, placing a marker between the hand and thumb stitches. Leave the remaining 6 thumb stitches on the third needle. From now on, the middle stitch of the thumb gore will be the first stitch on the third needle.

When the thumb gore is completed, there should be 21 (23, 25, 27, 31, 35) stitches for the thumb. Work the next round even. When you reach the thumb on the next round, use a tapestry needle to slip the thumb stitches to a thread or waste yarn. With MC, work M1 to replace the 1 seam stitch taken up by the thumb gore. Knit across the palm side of the mitten. You'll now have a total of 48 (56, 64, 72, 80, 92) stitches, with 12 (14, 16, 18, 20, 23) stitches on each of 4 needles.

Follow the hand chart (for your size), once for the back and once for the palm, until you are ready to decrease for the tip as shown on the chart. Remember to work the first two seam stitches on the right side of the chart before working the pattern section, then end with the last seam stitch on the left side of the chart. Continue to work the seam stitches in the pattern while working the decreases. When knitting a single-color round, slip the alternate color seam stitch from the round below to maintain seam-line integrity.

Tip Decreases and Finishing

Needle 1: K1 MC, K1 CC, ssk in pattern color. Knit to the end of the needle.
Needle 2: Knit to within 3 stitches of the end of the second needle, K2tog in pattern, K1 (CC).
Needle 3: Repeat as for needle 1.
Needle 4: Repeat as for needle 2.

Continue to decrease this way for every round, until 16 stitches remain, 4 sts on each needle (5 pattern stitches plus 3 seam stitches for both the palm and the back of the hand). Break the yarn, leaving about 15" of the background color. Transfer the stitches to 2 needles.

Use the Kitchener stitch to finish the top of the mitten as follows. Thread the yarn attached to the back needle (the needle that's away from you). Then, starting with the stitches on the front needle (the needle that's near to you), insert the tapestry needle into the first stitch of the front needle as if to purl, pull the yarn through but leave the stitch on the knitting needle.

Go to the back needle, being careful to take the yarn under the needle each time. Insert the tapestry needle into the first stitch as if to knit, pull the yarn through but leave the stitch on the knitting needle.

* Insert the tapestry needle into the first stitch of the front needle as if to knit, and then slip this stitch onto the tapestry needle. Insert the tapestry needle into the second stitch of the front needle as if to purl, pull the yarn through but leave the stitch on the knitting needle. Go to the back needle and insert the tapestry needle into the first stitch as if to purl. Slip this stitch onto the tapestry needle. Insert the tapestry needle through the second stitch of the back needle as if to knit. Pull the yarn through, but leave the second stitch on the knitting needle.*

Repeat from * to * until all stitches are joined. Do not draw the yarn too tightly. The stitches should have the same tension as the knitted stitches. Fasten end securely.

Thumb Finishing

With the body complete, you're ready to finish the thumb. Slip the 21 (23, 25, 27, 31, 35) stitches of the thumb from the holder onto 3 double-pointed needles: 9 (10, 10, 11, 12, 14) stitches on the first needle 3 (3, 5, 5, 7, 7) stitches on the second needle, and 9 (10, 10, 11, 12, 14) stitches on the third needle. Take the CC yarn and pick up 1 stitch in the CC seam stitch that is at the nearest side of the mitten. Place it on the end of the third needle.

Begin thumb round 1 with MC yarn, and pick up 1 stitch in the center seam stitch. Place it on the first needle. Pick up 1 CC stitch, following the center seam stitch, then follow the chart for the thumb until ready to decrease.

Needle 1: K1 MC, K1 CC, ssk, then knit to the end of the needle, following the pattern.
Needle 2: Knit all stitches.
Needle 3: Knit to within 3 stitches of the end of the needle, K2tog, and then knit the seam stitch.

Repeat the decreases until there are 8 (8, 10, 10, 12, 12) stitches left. Transfer the stitches from each needle to two needles: 4 (4, 5, 5, 6, 6) stitches on the front and back. Break the yarn, leaving a tail approximately 12" long for working the Kitchener stitch with background color as for the mitten top. Weave in all ends.

Blocking

Turn the mittens inside out. Place them in a bowl of room-temperature water for at least 30 minutes. Gently squeeze the water out of the mittens, and then roll them in a towel to remove the excess water. Lay them flat to dry out of direct sunlight. I actually dry them over a wooden spoon in a vase so that they dry faster. When dry, turn right side out and enjoy.

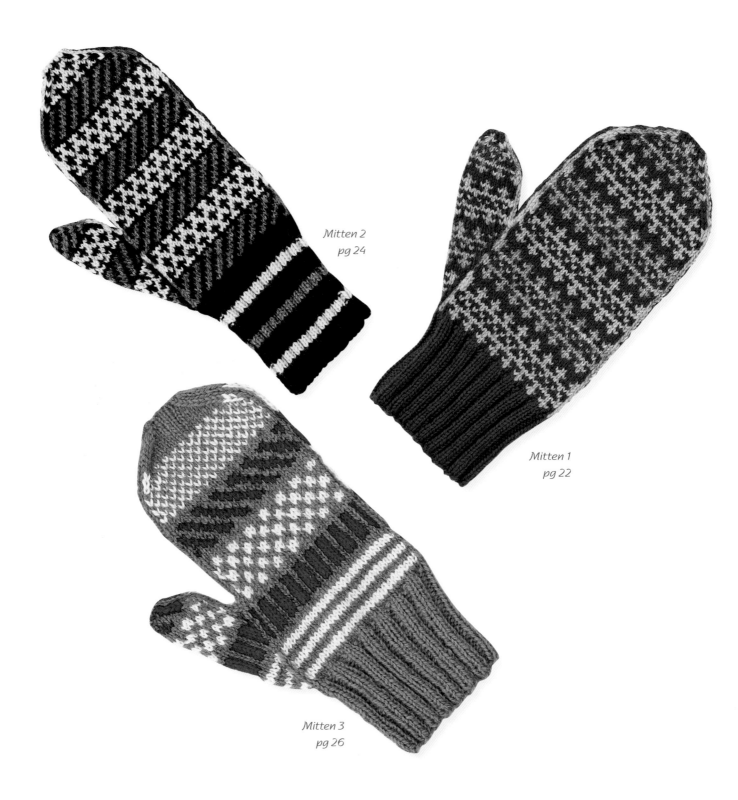

Mitten 2
pg 24

Mitten 1
pg 22

Mitten 3
pg 26

20

Basic Patterns

If you were given materials and asked to devise simple two-color patterns, there would be oodles of patterns you could create. In some of the mittens, several simple patterns are combined to create what at first looks like a complicated pattern, such as Mitten 1 (page 22). Upon closer inspection, you'll see it's really two simple patterns that have been stacked together; this is the basic premise.

These patterns are the simplest system of Komi decoration. They are easy to understand and thus easy to follow while knitting. The patterns are used in borders and as reticulations, which are allover netlike patterns. Some mittens are knit with two or more basic patterns stacked in borders, such as Mitten 2 (page 24). Others use a variety of patterns that do not repeat, such as Mitten 3 (page 26).

The basic borders were also interspersed with other borders and some reticulations, becoming a major portion of a mitten's hand after the fancy patterning at the cuff was completed. Other simple reticulations were used that were more complex than the basic patterns, yet didn't fit within the other systems of patterning. Mitten 26 (page 78) is an example of this, being a pattern reminiscent of Scandinavian knitting.

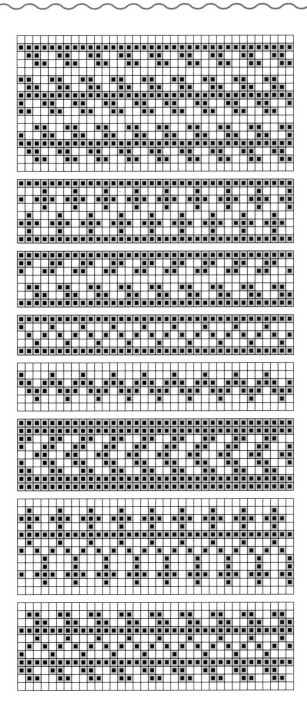

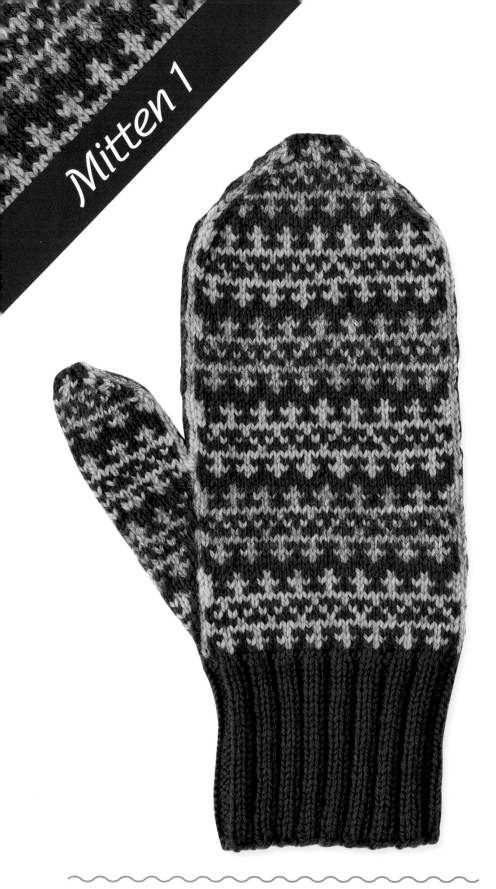

Mitten 1

Skill Level

Intermediate ■■■◻

Sizes

Adult's Medium (Large)

Yarn

Brown Sheep Nature Spun Sport (100% wool; 50 g; 184 yds) **2**
MC: 1 skein in color Medium Blue
CC1: 1 skein in color Light Gray
CC2: 1 skein in color Medium Pink

Needles

Set of 5 double-pointed needles in size 2 (2.75 mm) or size to obtain gauge

Gauge

16 sts and 18 rnds = 2" over two-color St st worked in the rnd

Reticulation

4 sts by 12 rnds

Instructions

Using MC, CO 64 (72) sts; join. Work in K2, P2 ribbing until cuff measures 3½ (3¾").

Work hand and thumb, following chart, opposite.

Though intricate looking, the overall pattern incorporates only two simple patterns, the cross and zigzag. The repeat is only 4 stitches wide, making it easy to memorize while working.

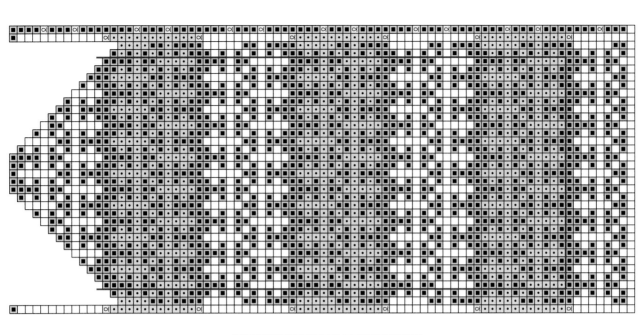

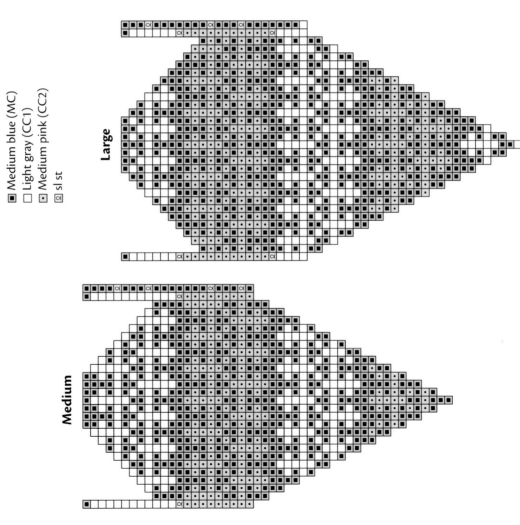

Medium blue (MC)
Light gray (CC1)
Medium pink (CC2)
sl st

Large

Medium

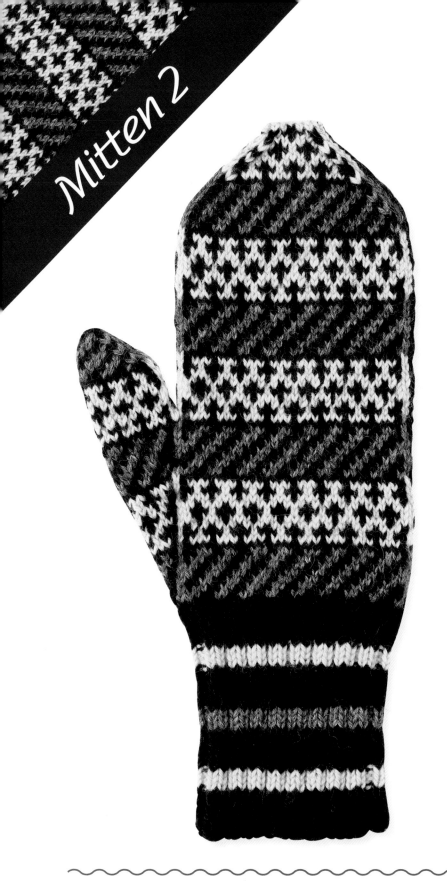

Skill Level

Intermediate ◼◼◼◻

Sizes

Adult's Medium (Large)

Yarn

Heilo from Dale of Norway (100% wool; 50 g; 109 yds) ②
MC: 2 skeins in color Dark Purple
CC1: 1 skein in color Yellow
CC2: 1 skein in color Medium Gray

Needles

Set of 5 double-pointed needles in size 2 (2.75 mm) or size to obtain gauge

Gauge

16 sts and 18 rnds = 2" over two-color St st worked in the rnd

Instructions

Using MC, CO 64 (72) sts; join.

Work K2, P2 ribbing in stripes as follows until cuff measures 3½ (3¾)".

5 (7) rnds MC
3 rnds CC1
7 rnds MC
3 rnds CC2
5 (7) rnds MC
3 rnds CC1
5 (7) rnds MC.

Work hand and thumb, following chart, opposite.

This mitten features two simple patterns that both repeat over four stitches. You can easily substitute colors to match a favorite jacket or use more colors from your yarn stash.

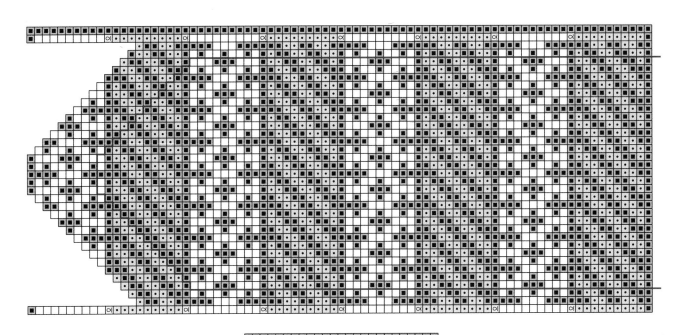

Legend:
- ■ Dark purple (MC)
- □ Yellow (CC1)
- ▨ Medium gray (CC2)
- · sl st

Large

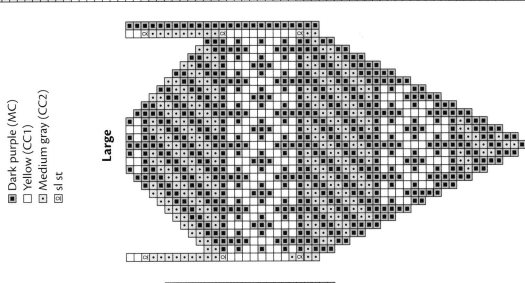

Medium

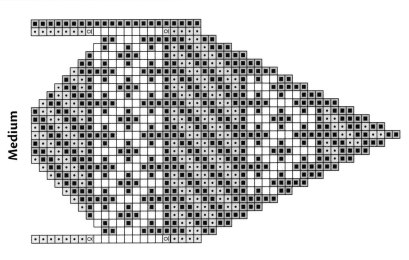

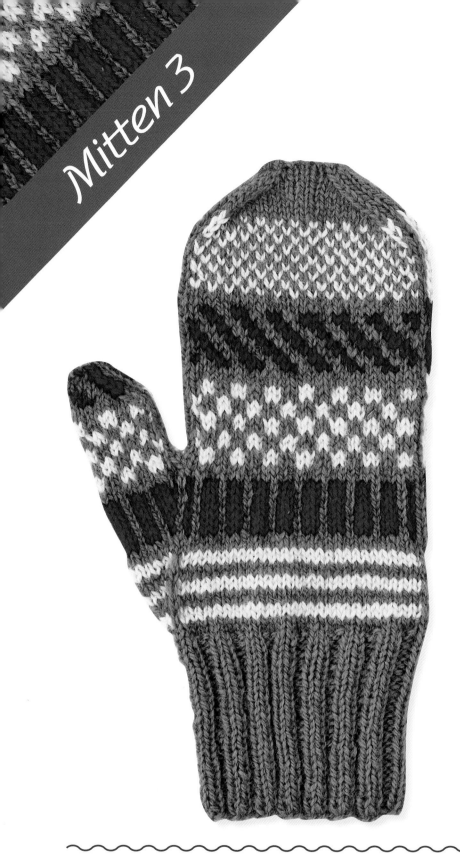

Mitten 3

Skill Level

Intermediate ■■■□

Sizes

Child's Medium (Large)

Yarn

Finullgarn 2-ply from Nordic Fiber Arts (100% wool; 50 g; 178 yds) (2)
MC: 1 skein in color Dark Turquoise
CC1: 1 skein in color Yellow
CC2: 1 skein in color Red

Needles

Set of 5 double-pointed needles in size 3 (3.25 mm) or size to obtain gauge

Gauge

16 sts and 18 rnds = 2" over two-color St st worked in the rnd

Instructions

Using MC, CO 48 (56) sts; join. Work in K2, P2 ribbing until cuff measures 2¾ (3)".

Work hand and thumb, following chart, opposite.

These easy patterns are satisfying to look at and a pleasure to work. The patterns are repeats of 1 stitch by 2 rounds, 4 stitches by 4 rounds, 2 stitches by 2 rounds, and 3 stitches by 1 round.

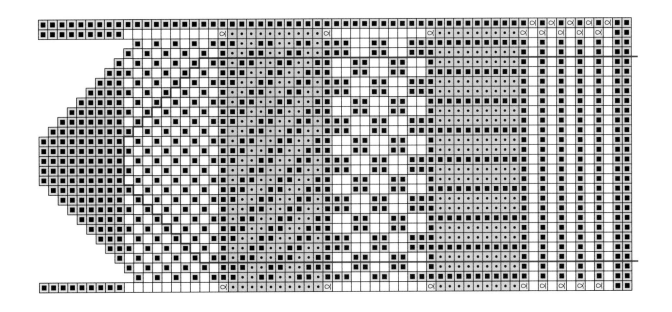

Dark turquoise (MC)
□ Yellow (CC1)
• Red (CC2)
☒ sl st

Large

Medium

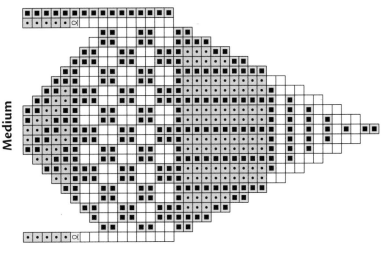

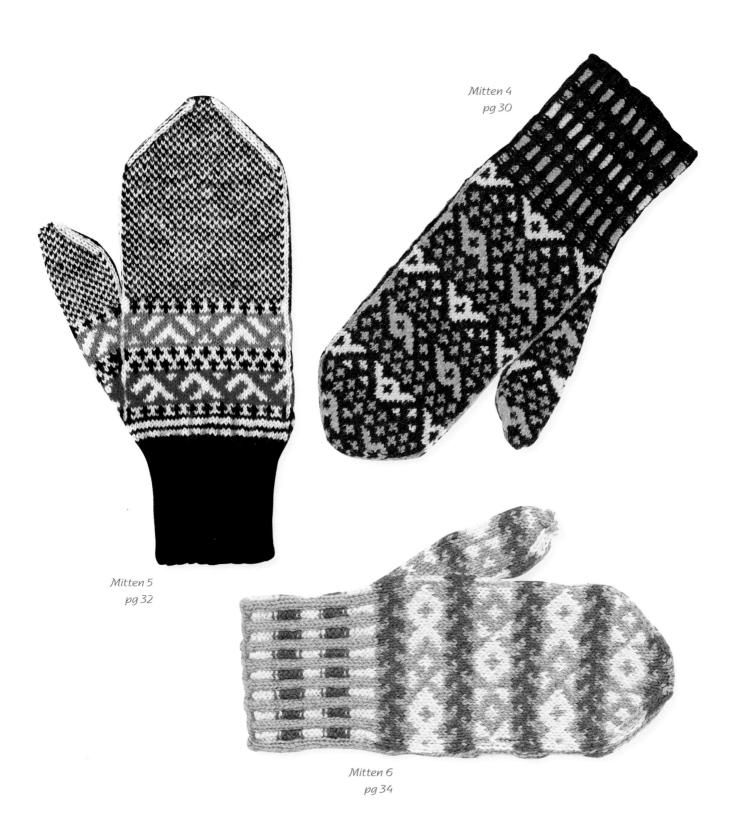

Mitten 4
pg 30

Mitten 5
pg 32

Mitten 6
pg 34

28

Septenary Borders

The Komi used these borders either consecutively or alternated them with borders created by the basic patterns. They are also used with wider borders on mittens or stockings. Septenary borders are created by isolating seven rows of larger reticulations. They follow the rules of reticulations (see page 55) and are symmetrical around a full three-stitch cross with two stitches above and two below.

The same pattern is used as light on dark as well as dark on light, which sometimes gives quite a different look to the pattern. Most of the repeats in the borders are 18 stitches wide, although some are 12 or 24 stitches wide.

You can see patterns (a) and (b) in the chart are both seven rounds high; however, they do not follow the rules for creation that the other patterns do. This indicates that they may have been created later or brought to the area from another ethnic group.

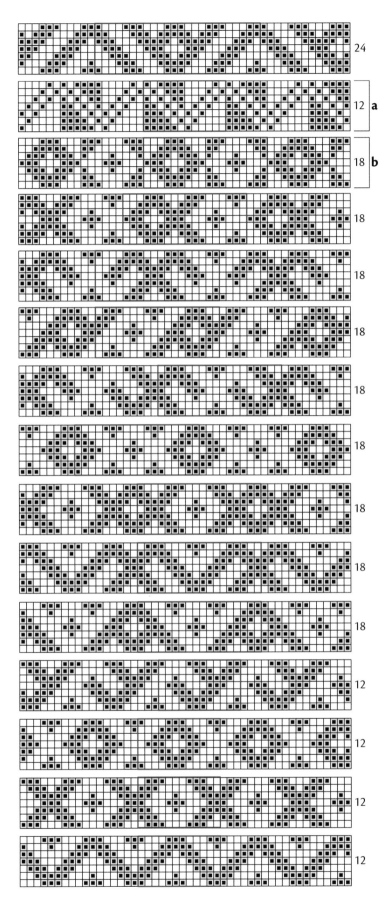

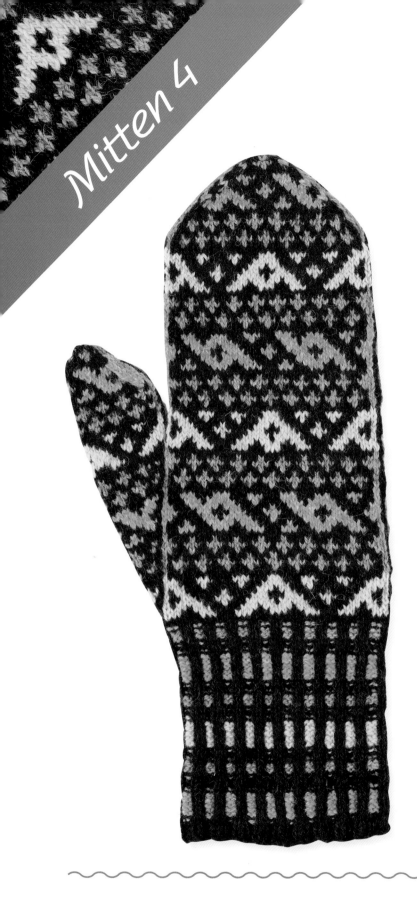

Skill Level

Experienced ■■■□

Size

Adult's Medium (Large)

Yarn

New England Shetland from Harrisville Designs (100% wool; 50 g; 217 yds) **1**

MC: 2 skeins in color Teak
CC1: 1 skein in color Gold
CC2: 1 skein in color Cornsilk
CC3: 1 skein in color Seagreen

Needles

Set of 5 double-pointed needles in size 0 (2 mm) or size to obtain gauge

Gauge

20 sts and 22 rnds = 2" over two-color St st worked in the rnd

Instructions

Using MC, CO 80 (92) sts; join. Work corrugated ribbing (page 14) using MC (knit) and CC (purl) until cuff measures 3½ (3¾)". Work in stripes as follows:

2 rnds MC
5 rnds CC1
2 rnds MC
2 rnds CC3
2 rnds MC
5 rnds CC2
2 rnds MC
2 rnds CC3
2 rnd MC
5 rnds CC1
2 rnds MC
2 rnds CC3
2 rnds MC

Work hand and thumb, following charts, opposite.

With two different septenary borders and a repeating four-stitch border, this mitten is similar to Mitten 6. For this mitten each of the septenary borders is knit in a different color.

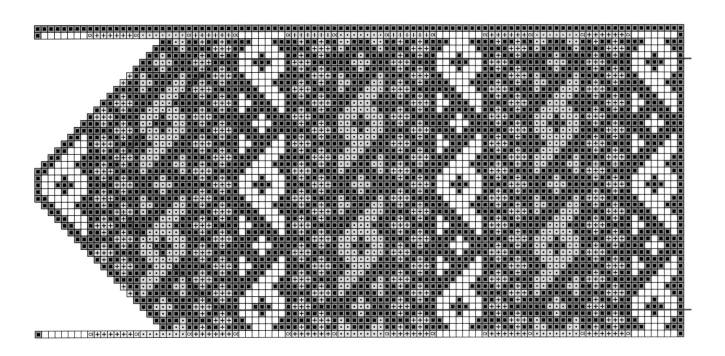

Teak (MC)
Gold (CC1)
Cornsilk (CC2)
Seagreen (CC3)
sl st

Large

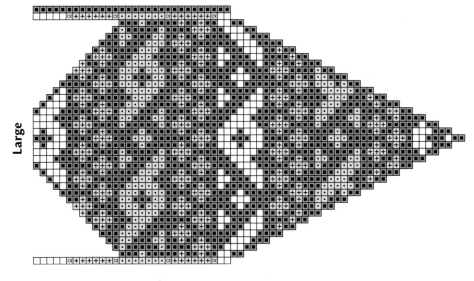

Medium

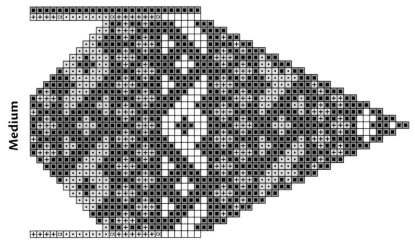

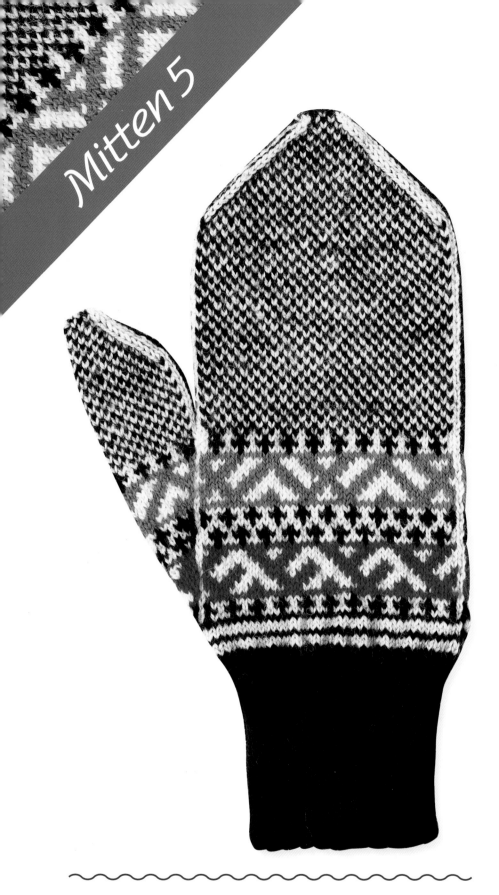

Skill Level

Intermediate ■■■□

Sizes

Adult's Medium (Large)

Yarn

Helmi Vuorelma Oy Satakieli 2-ply (100% wool; 100 g; 357 yds) 🧶**1**
MC1: 1 skein in color Black
MC2: 1 skein in color White
CC1: ½ skein in color Green
CC2: ½ skein in color Red

Needles

Set of 5 double-pointed needles in size 0 (2 mm) or size to obtain gauge

Gauge

20 sts and 22 rnds = 2" over two-color St st worked in the rnd

Instructions

Using MC1, CO 80 (92) sts; join. Work in K2, P2 ribbing until cuff measures 3½ (3¾)".

Work hand and thumb, following chart, opposite.

Two septenary borders, a four-stitch cross pattern, stripes, and a 2-stitch-by-2-round checkerboard make this a pleasing pattern.

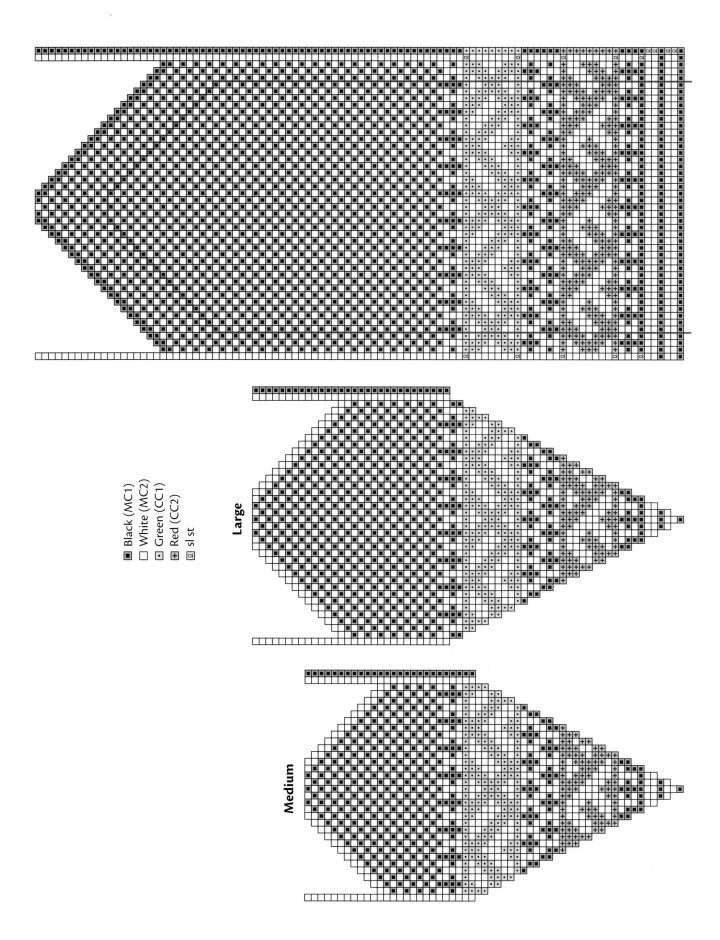

Black (MC1)
White (MC2)
Green (CC1)
Red (CC2)
sl st

Large

Medium

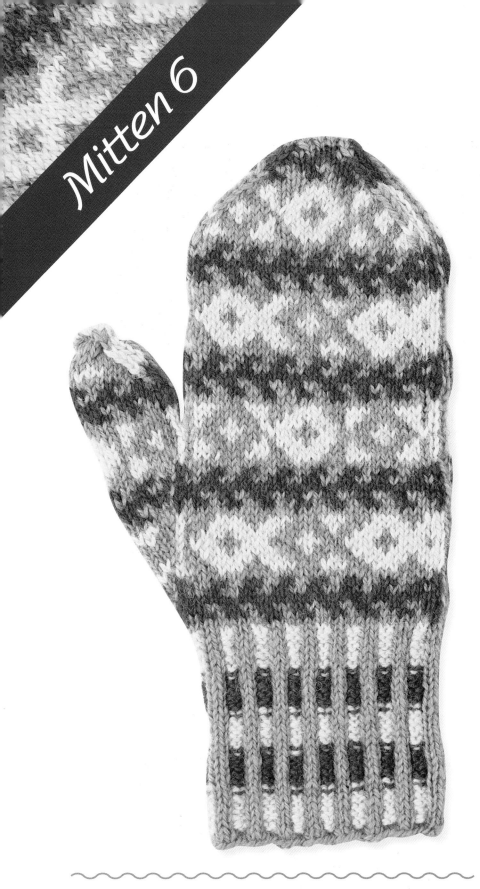

Skill Level

Experienced ■■■☐

Sizes

Child's Medium (Large)

Yarn

Finullgarn 2-ply from Nordic Fiber Arts (100% wool; 50 g; 178 yds) **2**
MC: 1 skein in color Green
CC1: 1 skein in color Yellow
CC2: 1 skein in color Pink

Needles

Set of 5 double-pointed needles in size 3 (3.25 mm) or size to obtain gauge

Gauge

16 sts and 18 rnds = 2" over two-color St st worked in the rnd

Instructions

Using MC, CO 48 (56) sts; join. Work cuff in corrugated ribbing (page 14), knitting MC sts and purling CC sts as follows:

5 (7) rnds CC1
5 rnds CC2
5 rnds CC1
5 rnds CC2
5 (7) rnds CC1

Cuff should measure 2¾ (3)".

Work hand and thumb, following charts, opposite.

Like Mitten 4, this mitten's design combines two different septenary borders with a repeating four-stitch border. To my eye, the four-stitch border resembles arrowheads or a vine.

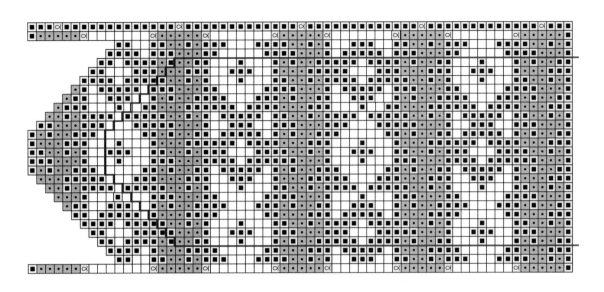

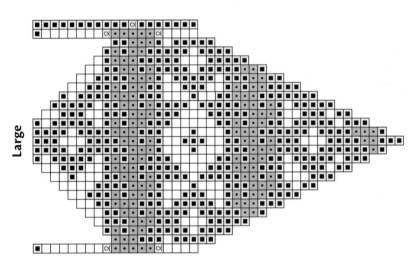

Large

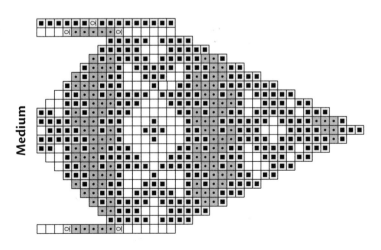

Medium

Green (MC)
Yellow (CC1)
Pink (CC2)
sl st

Wide Borders

These patterns can be used as complete wide borders, allover patterns, septenary borders, or borders combined with basic patterns. The chart, opposite, provides an example of how a pattern can be worked as (a) a reticulation; (b) a wide border 27 rounds high; c) a border 13 rounds high; and (d) a septenary border. The pattern shown is used for Mitten 10 on page 44.

Mitten 10
pg 44

Mitten 8
pg 40

Mitten 7
pg 38

Mitten 9
pg 42

Mitten 12
pg 48

Mitten 11
pg 46

Mitten 13
pg 50

Mitten 14
pg 52

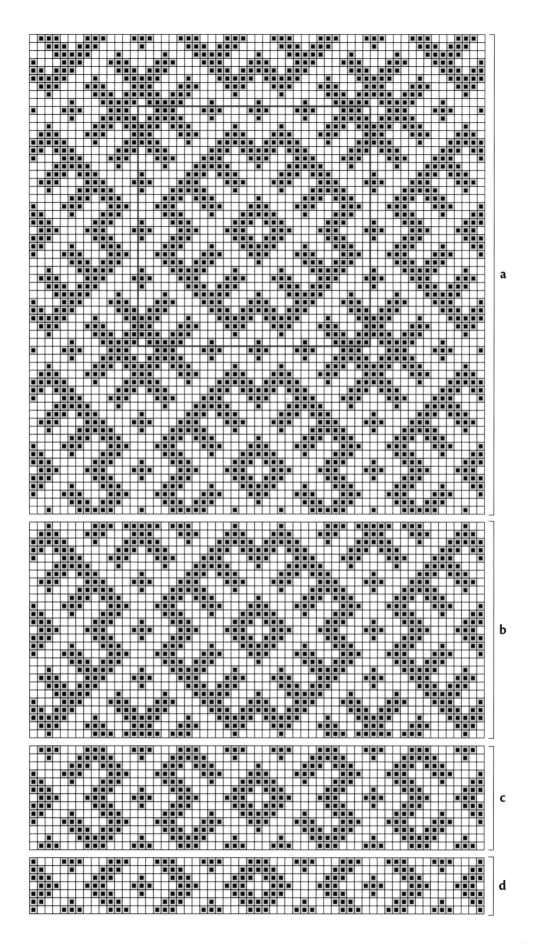

a

b

c

d

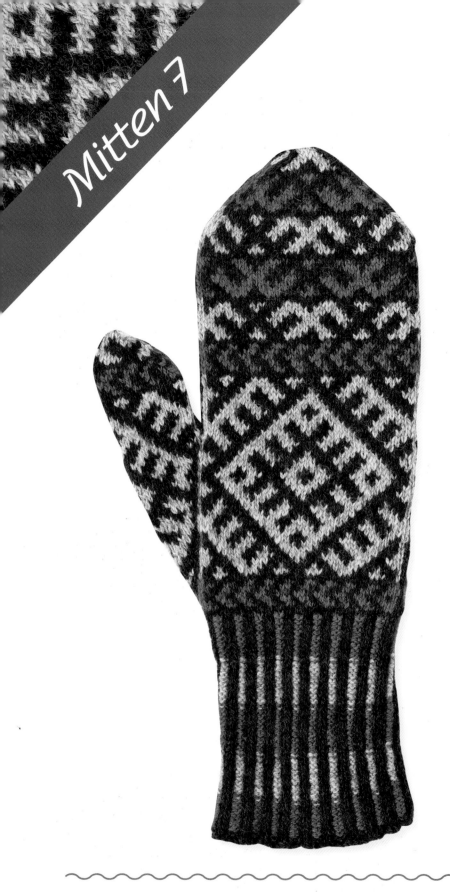

Skill Level

Experienced ■■■▬

Size

Adult's Medium (Large)

Yarn

New England Shetland from Harrisville Designs (100% wool; 50 g; 217 yds)) **2**
MC: 2 skeins in color Cypress
CC1: 1 skein in color Oatmeal
CC2: 1 skein in color Olive

Needles

Set of 5 double-pointed needles in size 0 (2 mm) or size to obtain gauge

Gauge

20 sts and 22 rnds = 2" over two-color St st worked in the rnd

Reticulation

60 sts by 48 rnds

Instructions

Using MC, CO 80 (92) sts; join.

Work cuff in corrugated ribbing (page 14), knitting MC sts and purling CC sts as follows: work 6 (7) rnd stripes of each CC1 and CC2, alternating colors until cuff measures 3½ (3¾)".

Work hand and thumb, following charts, opposite.

Some patterns seem to be only borders. After much thought, I determined that this border, though it's the largest, doesn't lend itself to becoming a reticulation.

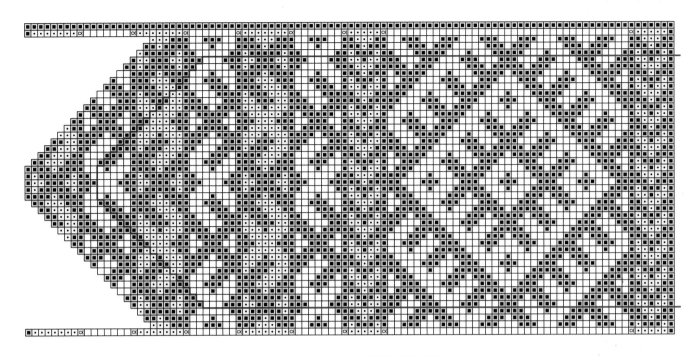

■ Cypress (MC)
☐ Oatmeal (CC1)
· Olive (CC2)
☒ sl st

Large

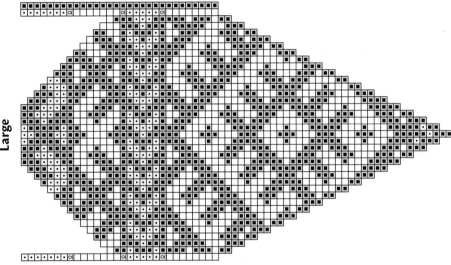

Medium

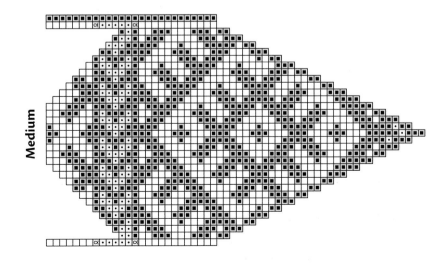

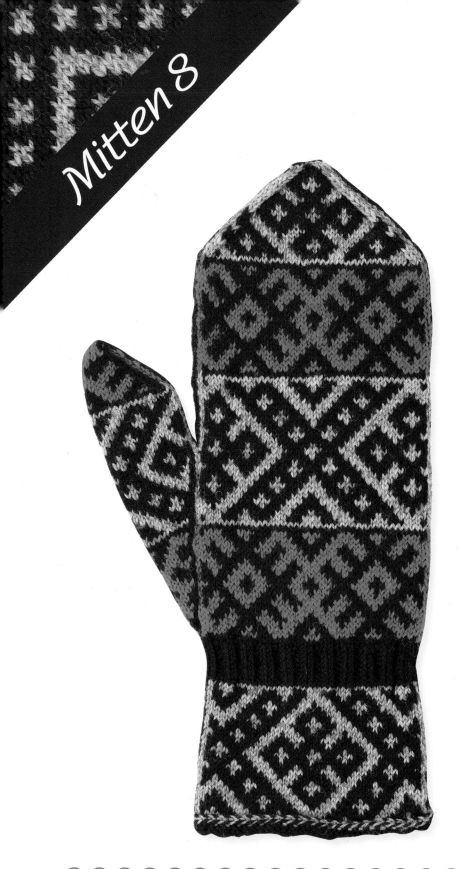

Skill Level

Intermediate ■■■□

Size

Adult's Medium (Large)

Yarn

Nature Spun Fingering from Brown Sheep Company, Inc. (100% wool; 50 g; 310 yds) (1)
MC: 1 skein in color Reddish Brown
CC1: 1 skein in color Orange
CC2: 1 skein in color Light Tan

Needles

Set of 5 double-pointed needles in size 1 (2.25 mm) or size to obtain gauge

Gauge

20 sts and 22 rnds = 2" over two-color St st worked in the rnd

Reticulations

36 sts by 36 rnds; 24 sts by 24 rnds

Instructions

Using MC and CC2, CO 80 (92) sts using twisted edge CO (see "Patterned Two-Color Cuffs" on page 14). Work cuff from chart, opposite, for 33 rows (until first break in pattern). Work ¾" of K2, P2 ribbing using MC.

Work hand and thumb, following chart, opposite.

By centering two patterns with different repeats, I was able to devise a larger pattern where the two work harmoniously together.

Connect to 33-row cuff

Cuff
33 rows

Large

Medium

■ Reddish brown (MC)
· Orange (CC1)
□ Light tan (CC2)
▦ ¾" of K2, P2 ribbing in MC
⊠ sl st

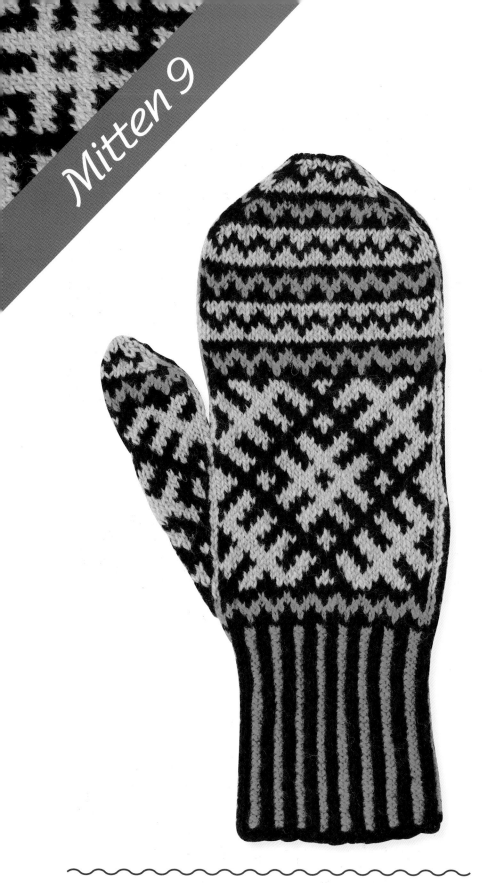

Skill Level

Intermediate ◼◼◼◻

Sizes

Adult's Medium (Large)

Yarn

Finullgarn 2-ply from Nordic Fiber Arts (100% wool; 50 g; 178 yds) **2**
MC: 1 skein in color Brown
CC1: 1 skein in color Yellow
CC2: 1 skein in color Orange

Needles

Set of 5 double-pointed needles in size 3 (3.25 mm) or size to obtain gauge

Gauge

16 sts and 18 rnds = 2" over two-color St st worked in the rnd

Reticulation

30 sts by 30 rnds

Instructions

Using MC, CO 64 (72) sts; join. Work cuff in corrugated ribbing (page 14), using MC (knit) and CC2 (purl), until cuff measures 3½ (3¾)".

Work hand and thumb, following chart, opposite.

This bold crossed pattern is set off beautifully by the little zigzag borders. It would also make an impressive reticulation by itself.

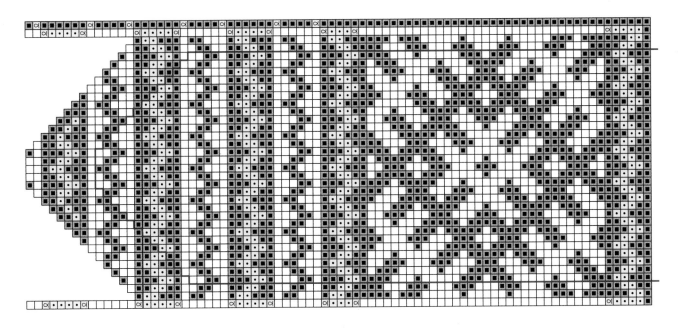

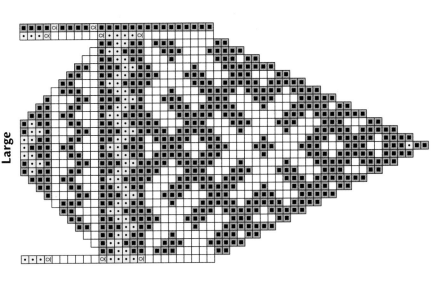

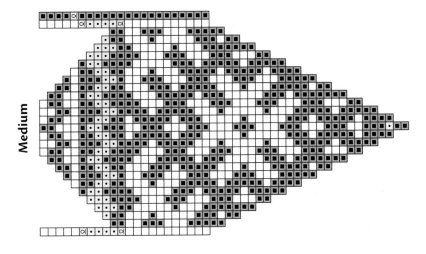

Large

Medium

■ Brown (MC)
□ Yellow (CC1)
⊡ Orange (CC2)
⊠ sl st

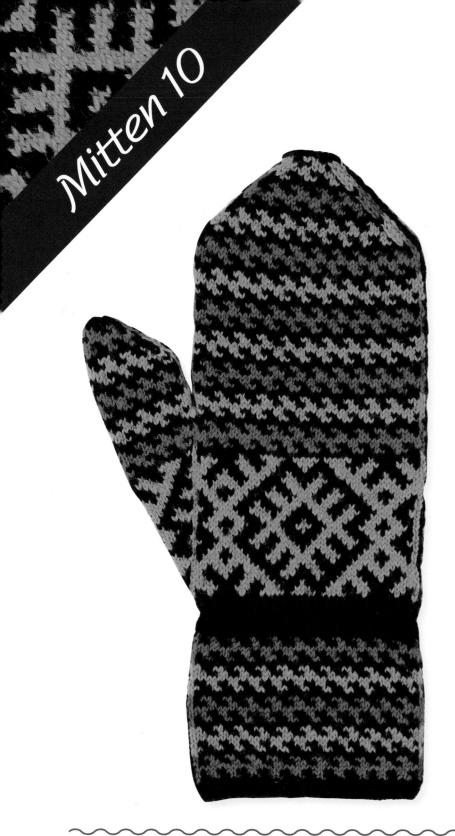

Skill Level

Intermediate ■■■▢

Sizes

Adult's Medium (Large)

Yarn

Nature Spun Fingering from Brown Sheep Company, Inc. (100% wool; 50 g; 310 yds) **1**
MC: 1 skein in color Navy Blue
CC1: 1 skein in color Gold
CC2: 1 skein in color Reddish Gold

Needles

Set of 5 double-pointed needles in size 1 (2.25 mm) or size to obtain gauge

Gauge

20 sts and 22 rounds = 2" over two-color St st worked in the rnd

Reticulation

30 sts by 30 rnds

Instructions

Using MC, CO 80 (92) sts; join. Work K1, P1 ribbing for ½". Work cuff patt from chart, opposite, for 31 rows (until first break in patt). Work ¾" of K2, P2 ribbing using MC. If you prefer, you may substitute an entire K2, P2 ribbed cuff of 3½ (3¾)".

Work hand and thumb, following chart, opposite.

The reticulation combines two of the most popularly used motifs: the two lines crossing and the three lines crossing, one light on dark, the other dark on light. The frame of dark stitches around the three lines crossing creates a beautiful motif for the border of the mitten.

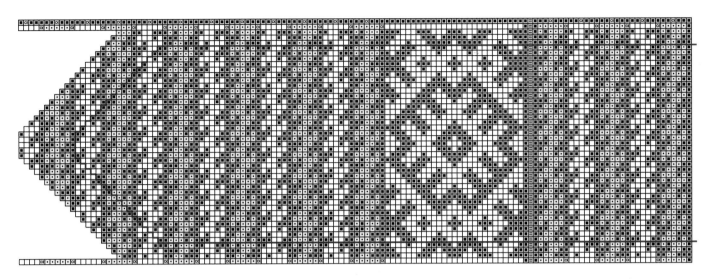

■ Navy blue (MC)
□ Gold (CC1)
· Reddish gold (CC2)
▥ ¾" of K2, P2 ribbing in MC
◨ sl st

Large

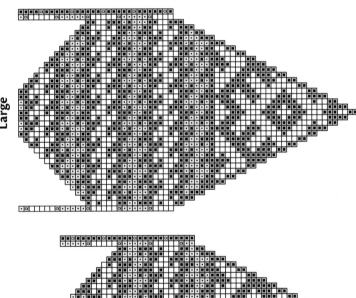

Medium

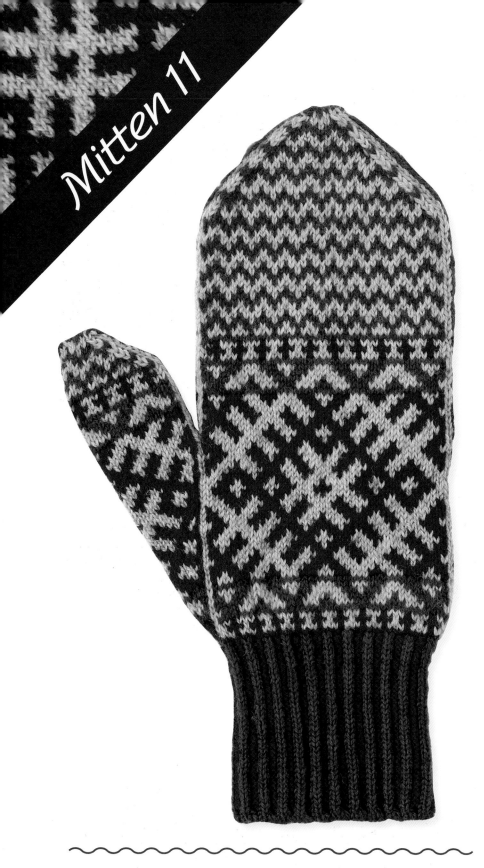

Mitten 11

Skill Level

Intermediate ◼◼◼◻

Sizes

Adult's Medium (Large)

Yarn

Nature Spun Fingering from Brown Sheep Company, Inc. (100% wool; 50 g; 310 yds) ❶

MC: 1 skein in color Dark Bluish Green
CC1: 1 skein in color Light Turquoise
CC2: 1 skein in color Medium Red

Needles

Set of 5 double-pointed needles in size 1 (2.25 mm) or size to obtain gauge

Gauge

20 sts and 22 rnds = 2" over two-color St st worked in the rnd

Reticulation

42 sts by 42 rnds

Instructions

Using MC, CO 80 (92) sts; join. Work in corrugated ribbing (page 14) using MC (knit) and CC2 (purl) until cuff measures 3½ (3¾)".

Work hand and thumb, following chart, opposite.

One large border combined with three easier patterns creates this design. You'll find a Komi-style pattern of four rounds, and two patterns worked with four-stitch repeats.

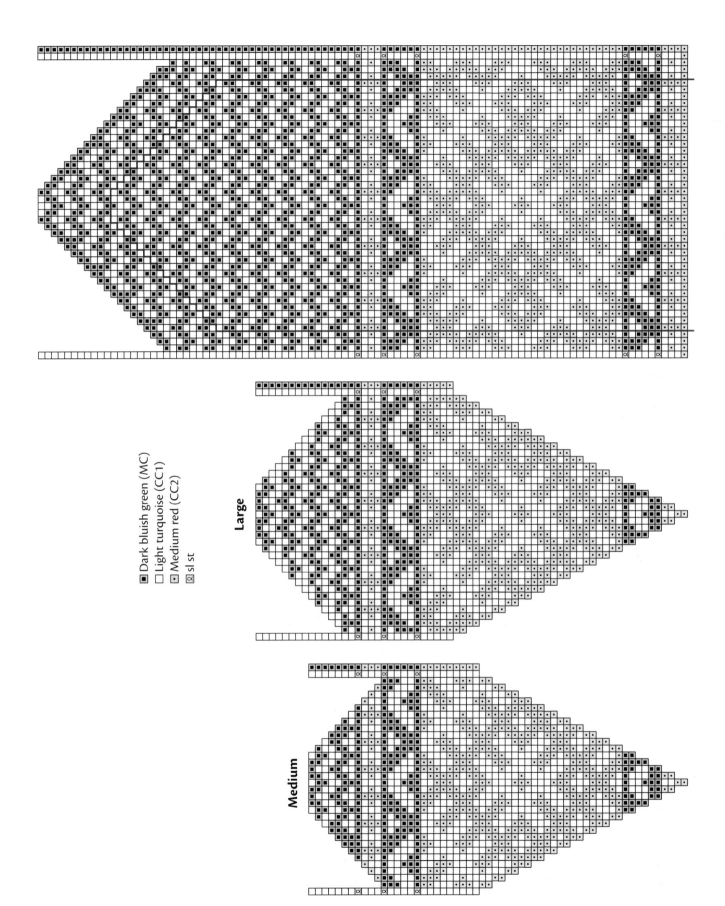

Dark bluish green (MC)
Light turquoise (CC1)
Medium red (CC2)
sl st

Large

Medium

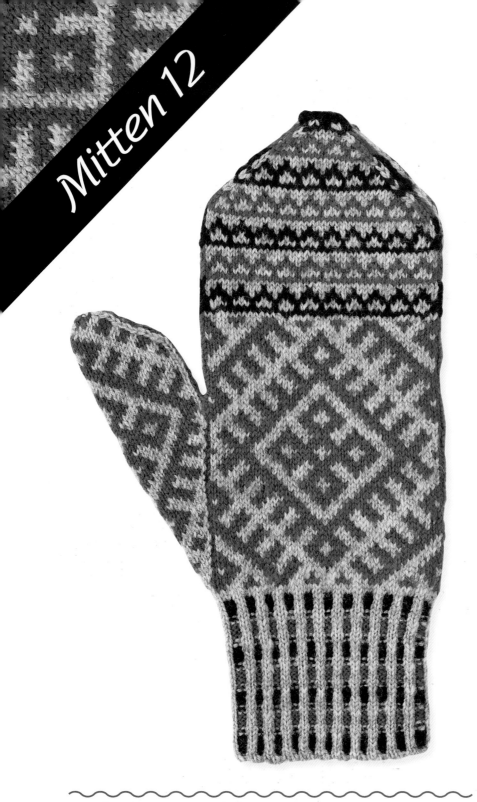

Skill Level

Intermediate ■■■□

Sizes

Adult's Medium (Large)

Yarn

Nature Spun Fingering from Brown Sheep Company, Inc. (100% wool; 50 g; 310 yds) **1**
MC: 1 skein in color Light Gray
CC1: 1 skein in color Turquoise
CC2: 1 skein in color Purple

Needles

Set of 5 double-pointed needles in size 1 (2.25 mm) or size to obtain gauge

Gauge

20 sts and 22 rnds = 2" over two-color St st worked in the rnd

Reticulation

42 sts by 54 rnds

Instructions

Using MC, CO 80 (92) sts; join. Work in corrugated ribbing (page 14), using MC (knit) and CC2 (purl) for 6 rnds. Then work 6 rnds using MC and CC1. Repeat, alternating 6-rnd stripes of MC, CC2, and CC1 until cuff measures 3½ (3¾)".

Work hand and thumb, following chart, opposite.

The core of this pattern is a star-type motif. At 42 stitches by 54 rounds, it's one of the largest reticulations in this book. Rather than knit the thumb with a partial turquoise star and partial purple stripe as would be the case if I kept the pattern in line with that of the body of the mitten, I modified the reticulation so that I could knit a full turquoise star pattern on the thumb.

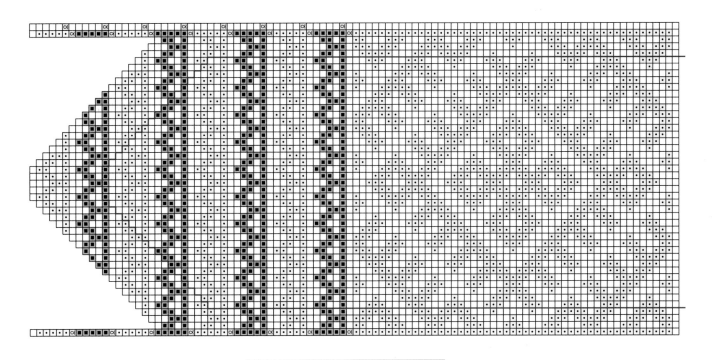

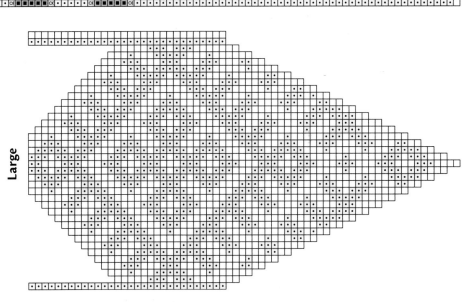

Large

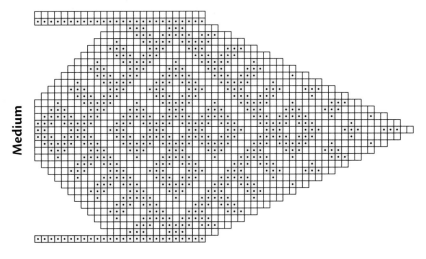

Medium

☐ Light gray (MC)
· Turquoise (CC1)
■ Purple (CC2)
⊠ sl st

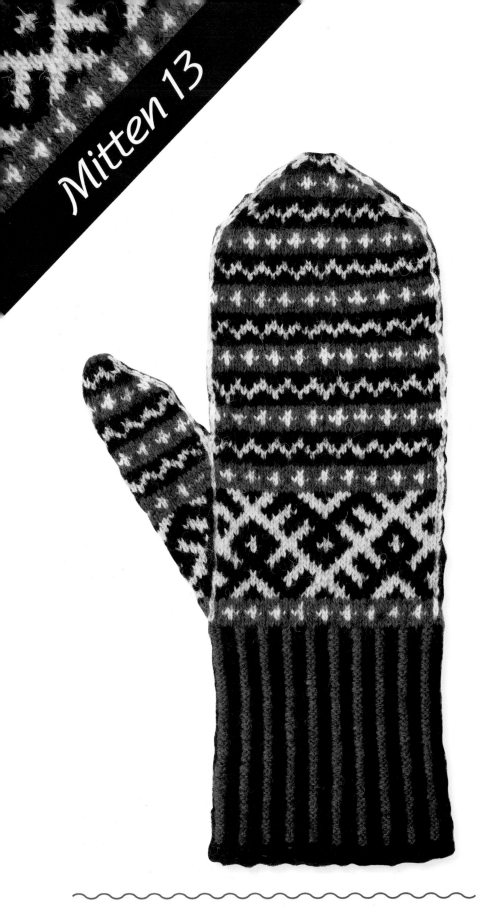

Skill Level

Experienced ◼◼◼◼

Size

Adult's Medium (Large)

Yarn

New England Shetland from Harrisville Designs (100% wool; 50 g; 217 yds) **1**

MC: 2 skeins in color Navy Blue
CC1: 2 skeins in color Azure
CC2: 1 skein in color Cornsilk
CC3: 1 skein in color White

Needles

Set of 5 double-pointed needles in size 0 (2 mm) or size to obtain gauge

Gauge

20 sts and 22 rnds = 2" over two-color St st worked in the rnd

Instructions

Using MC, CO 80 (92) sts; join. Work in corrugated ribbing (page 14) using MC (knit) sts and CC1 (purl) until cuff measures 3½ (3¾)".

Work hand and thumb, following chart, opposite.

When expanded into a reticulation, this pattern has only a horizontal axis. It makes a pleasing allover design.

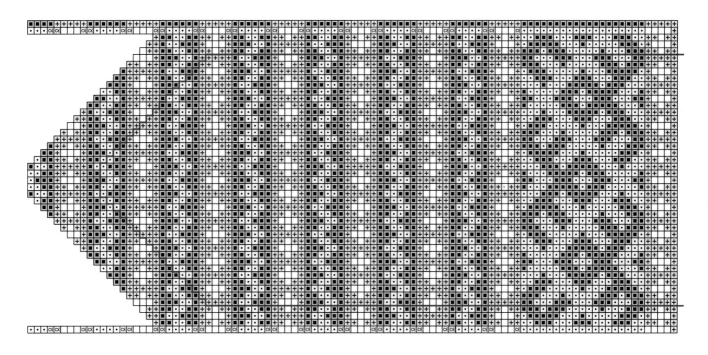

Navy (MC)
Azure (CC1)
Cornsilk (CC2)
White (CC3)
sl st

Large

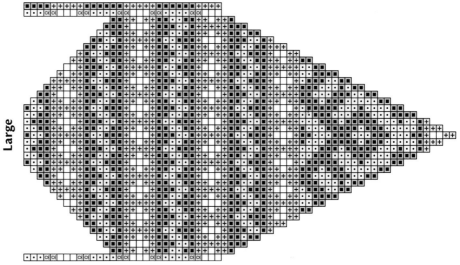

Medium

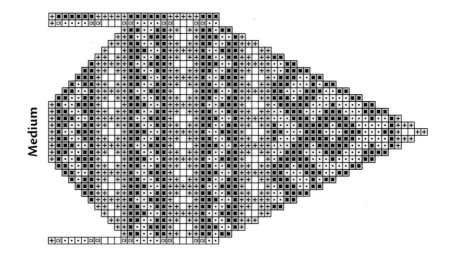

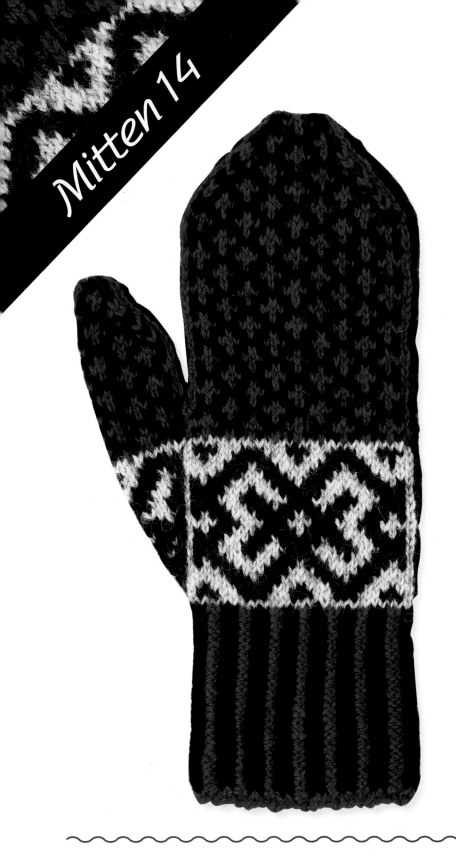

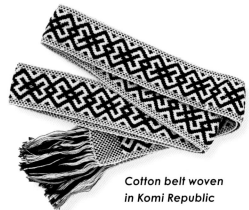

Cotton belt woven in Komi Republic

Skill Level

Intermediate ◼◼◼◻

Sizes

Child's Medium (Large)

Yarn

Finullgarn 2-ply from Nordic Fiber Arts (100% wool; 50 g; 178 yds)

[2]

MC: 1 skein in color Black
CC1: 1 skein in color Light Gray
CC2: 1 skein in color Medium Blue

Needles

Set of 5 double-pointed needles in size 3 (3.25 mm) or size to obtain gauge

Gauge

16 sts and 18 rnds = 2" over two-color St st worked in the rnd

Reticulation

24 sts by 18 rnds

Instructions

Using MC, CO 48 (56) sts. Work cuff in corrugated ribbing (page 14) using MC (knit) and CC2 (purl), until cuff measures 2¾ (3)".

Work hand and thumb, following chart, opposite.

I copied this pattern from a woven belt from the Komi Republic that was given to me. Although the actual belt pattern is a border, it can be repeated in a variety of ways to create a reticulation. The simple reticulation above the border is a repeat of 6 stitches by 4 rounds.

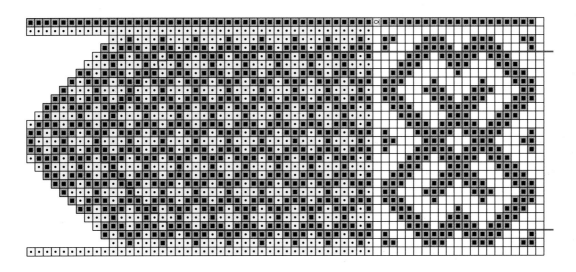

■ Black (MC)
☐ Light gray (CC1)
⊡ Medium blue (CC2)
☒ sl st

Large

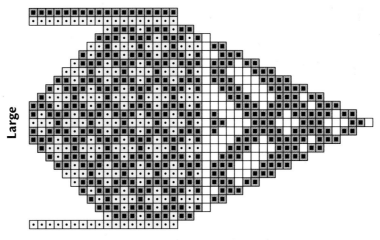

Medium

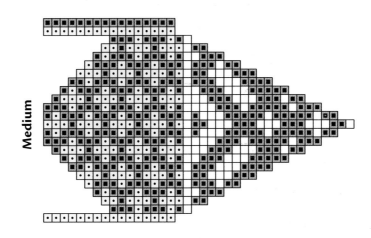

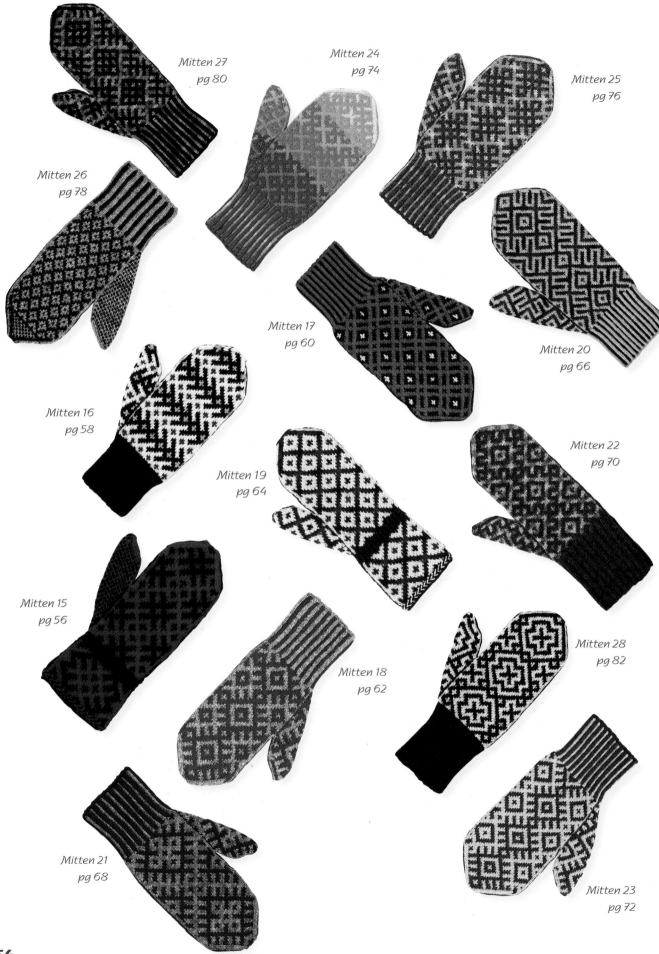

Mitten 27
pg 80

Mitten 24
pg 74

Mitten 25
pg 76

Mitten 26
pg 78

Mitten 17
pg 60

Mitten 20
pg 66

Mitten 16
pg 58

Mitten 19
pg 64

Mitten 22
pg 70

Mitten 15
pg 56

Mitten 18
pg 62

Mitten 28
pg 82

Mitten 21
pg 68

Mitten 23
pg 72

Reticulations

These patterns are the core of the magic of Komi patterning. Reticulations follow four rules:

1. The underlying pattern is the cross that is repeated, giving the whole fundamental pattern a repeat of 6 stitches by 6 rounds. This results in every third row being three dark and three light stitches.

2. The working patterns are created with knitted color repeats of 1, 3, and 5 only.

3. The lines of the design are three stitches wide.

4. The diagonal pattern is aligned on the vertical or horizontal axis. This can be the same pattern or two different alternating patterns. Mitten 10 is a good example of how patterns can alternate.

The chart shows how a pattern of 24 stitches by 24 rounds would be created. This pattern is symmetrical horizontally as well as vertically, and all the motifs are the same. A pattern line on the diagonal creates stronger knitted fabric than a vertical line. This works well with the technique of knitting, since the pattern moves diagonally across the fabric, allowing the floats across the back to also travel. This makes for a flatter fabric

and an almost-square stitch shape, rather than the short, wide stitch of a single-color stockinette stitch.

This style of pattern is used as a reticulation, but some have been adapted for use as borders by selecting a portion of the allover design. A favorite is the seven-row, or septenary, border, which follows most of the rules of the reticulations, but has only one axis. Borders can also be 10, 13, or more stitches wide. For symmetry it is best to begin and end a section of the reticulation with 3 light and 3 dark and with the pattern centered horizontally as well as vertically. When working with the reticulations, you'll find it's easy to combine the patterns into beautiful designs because of their appealing symmetry. As examples, Mitten 15 uses four patterns, a basic 6-stitch-by-6-round pattern, two reticulations, and a basic pattern on the thumb; Mitten 26 uses a basic 6-stitch-by-8-round pattern with a basic pattern on the thumb and tip. Always remember to center the patterns on the piece and be sure to relate the patterns to one another when stacking your borders.

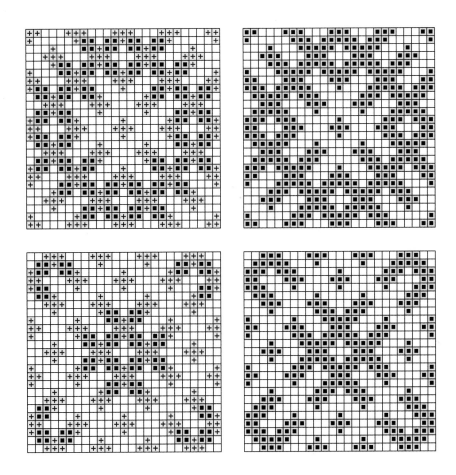

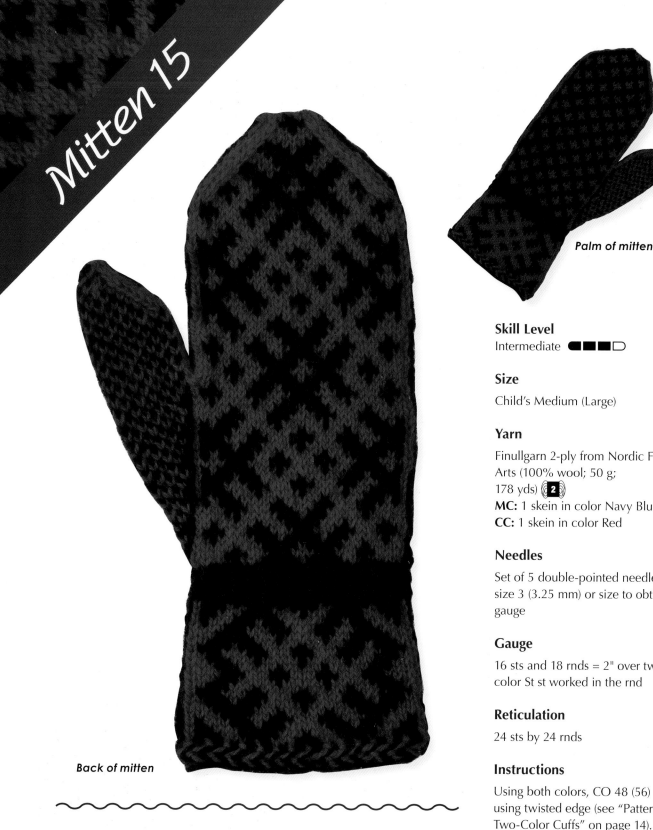

Back of mitten

Palm of mitten

Skill Level

Intermediate ◼◼◼◻

Size

Child's Medium (Large)

Yarn

Finullgarn 2-ply from Nordic Fiber Arts (100% wool; 50 g; 178 yds) [2]
MC: 1 skein in color Navy Blue
CC: 1 skein in color Red

Needles

Set of 5 double-pointed needles in size 3 (3.25 mm) or size to obtain gauge

Gauge

16 sts and 18 rnds = 2" over two-color St st worked in the rnd

Reticulation

24 sts by 24 rnds

Instructions

Using both colors, CO 48 (56) sts using twisted edge (see "Patterned Two-Color Cuffs" on page 14). Work the cuff, following the chart, opposite, for 19 rows (until first break in patt). Work ¾" of K2, P2 ribbing using MC.

Work hand and thumb, following chart, opposite.

It's always fun to see how a collection of Komi patterns can look together. I designed this mitten using three different patterns for the palm, thumb, and back; the chart on the right corresponds to the back, the chart on the left to the palm (or reverse as you please!). For a pair with stars on the palms, start the second mitten with the left-hand chart.

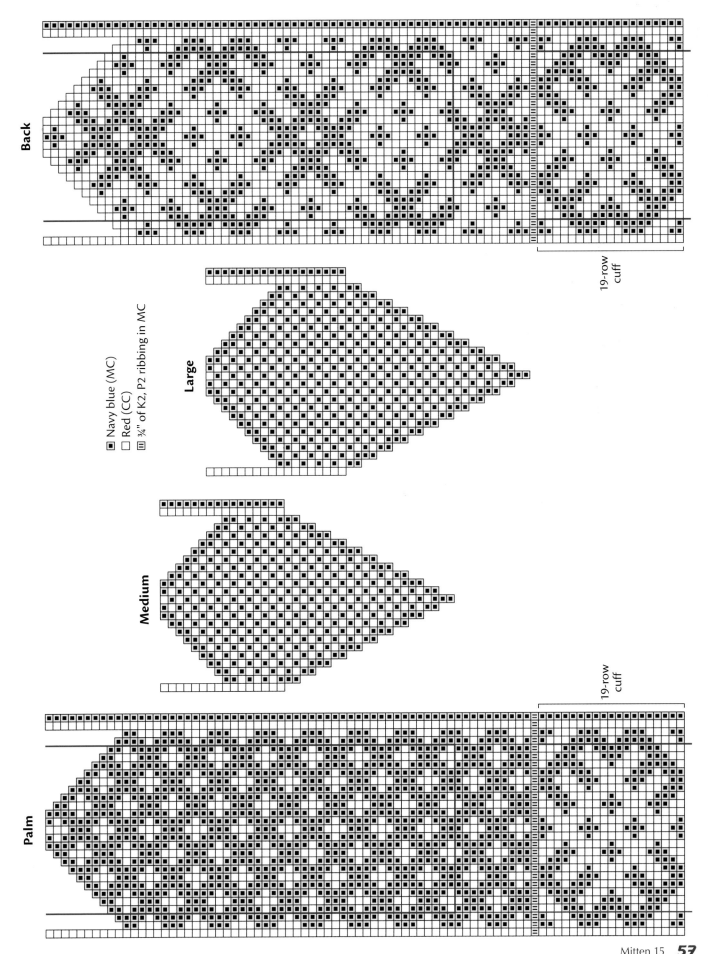

Back

Large

Medium

Palm

☒ Navy blue (MC)
☐ Red (CC)
▥ ¾" of K2, P2 ribbing in MC

19-row cuff

19-row cuff

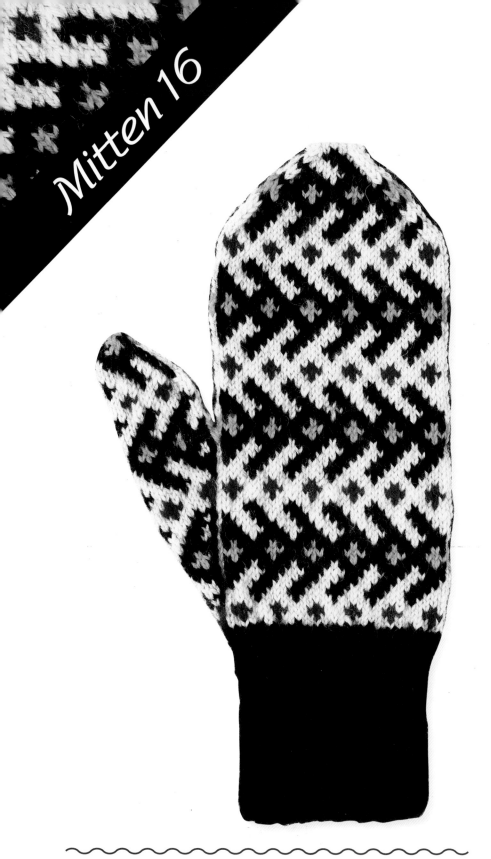

Skill Level

Experienced ▰▰▰▱

Sizes

Adult's Medium (Large)

Yarn

Finullgarn 2-ply from Nordic Fiber Arts (100% wool; 50 g; 178 yds) [2]
MC: 2 skeins in color Navy Blue
CC1: 1 skein in color White
CC2: 1 skein in color Red
CC3: 1 skein in color Gold

Needles

Set of 5 double-pointed needles in size 3 (3.25 mm) or size to obtain gauge

Gauge

16 sts and 18 rnds = 2" in two-color St st worked in the rnd

Reticulation

6 sts by 18 sts

Instructions

Using MC, CO 64 (72) sts; join. Work in K2, P2 ribbing until cuff measures 3½ (3¾)".

Work hand and thumb, following chart, opposite.

Given its apparent movement, this pattern was fun to contemplate when designing and fun to work when knitting. But look closer! The thumb pattern is reversed, adding extra interest to the design. You'll find a matching cap on page 102.

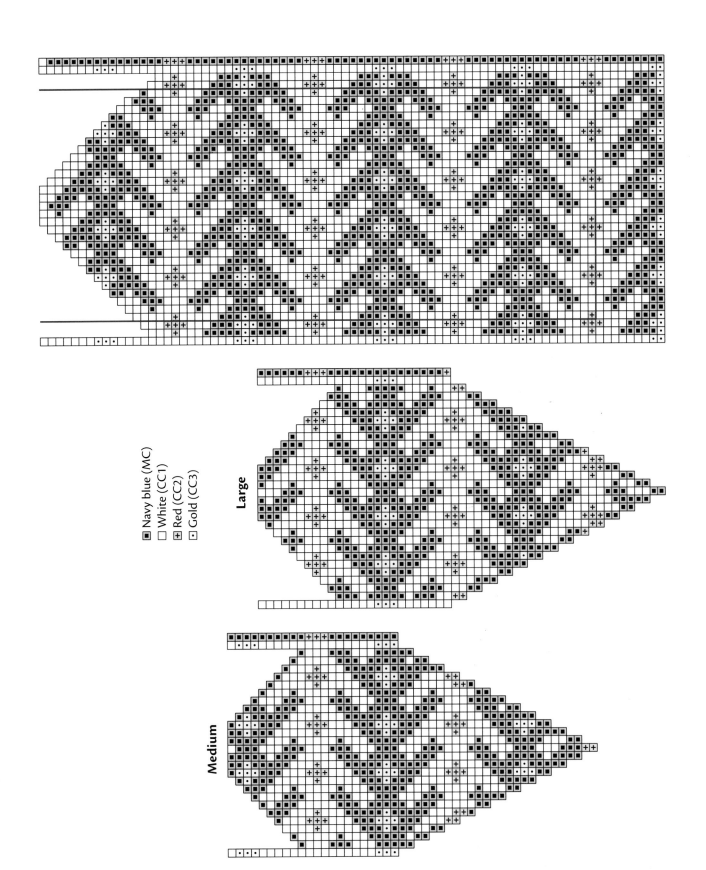

Navy blue (MC)
White (CC1)
Red (CC2)
Gold (CC3)

Large

Medium

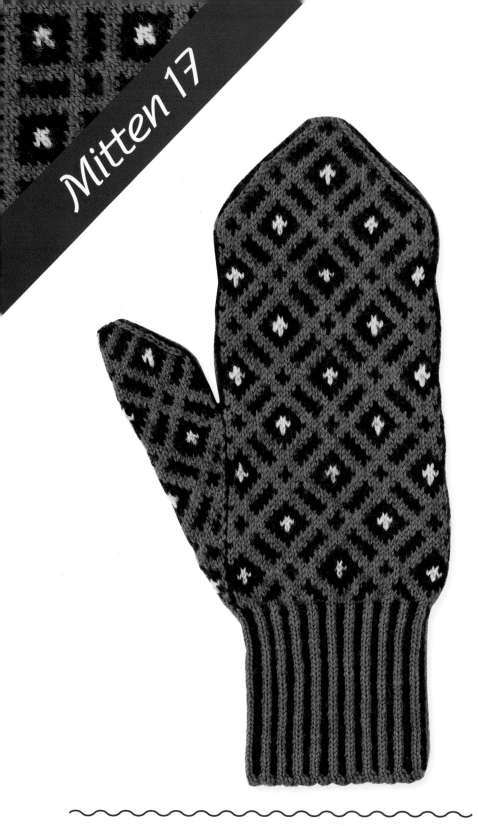

Mitten 17

Skill Level

Experienced ■■■■

Sizes

Adult's Medium (Large)

Yarn

Brown Sheep Nature Spun Fingering (100% wool; 50 g; 310 yds) 〔1〕
MC: 1 skein in color Medium Blue
CC1: 1 skein in color Dark Blue
CC2: 1 skein in color Cream

Needles

Set of 5 double-pointed needles in size 1 (2.25 mm) or size to obtain gauge

Gauge

20 sts and 22 rnds = 2" over two-color St st worked in the rnd

Instructions

Using MC, CO 80 (92) sts; join. Work corrugated ribbing (page 14) using MC (knit) and CC1 (purl) until cuff measures 3½ (3¾)".

Work hand and thumb, following chart, opposite.

The 18-stitch-by-18-round reticulation has cream-colored centers in the middle of the dark blue squares. To avoid carrying the cream color over 15 stitches, substitute the lighter blue for the cream color, making a two-color reticulation. Then make a duplicate stitch (see page 14) in the cream color, using approximately a 12" length for each center.

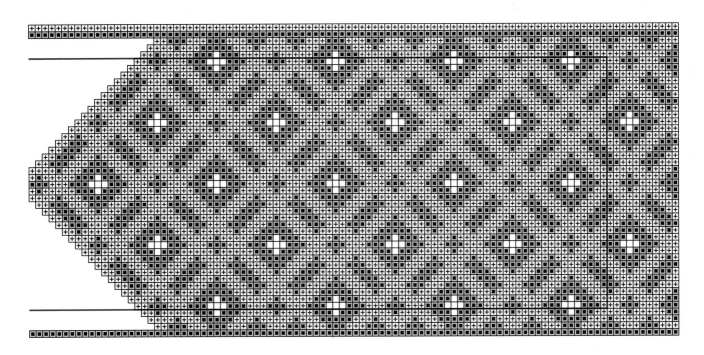

☐ Medium blue (MC)
■ Dark blue (CC1)
☐ Cream (CC2)

Large

Medium

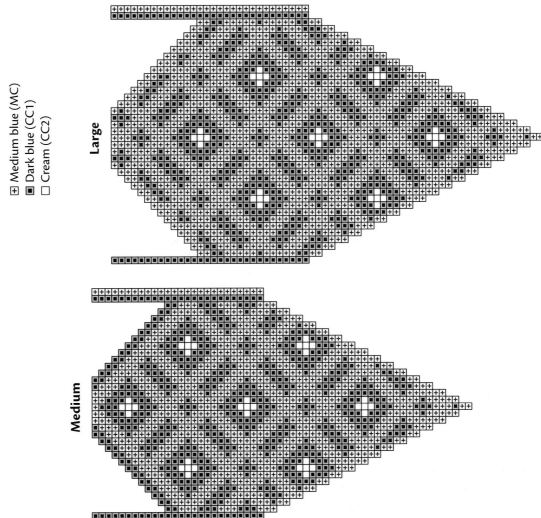

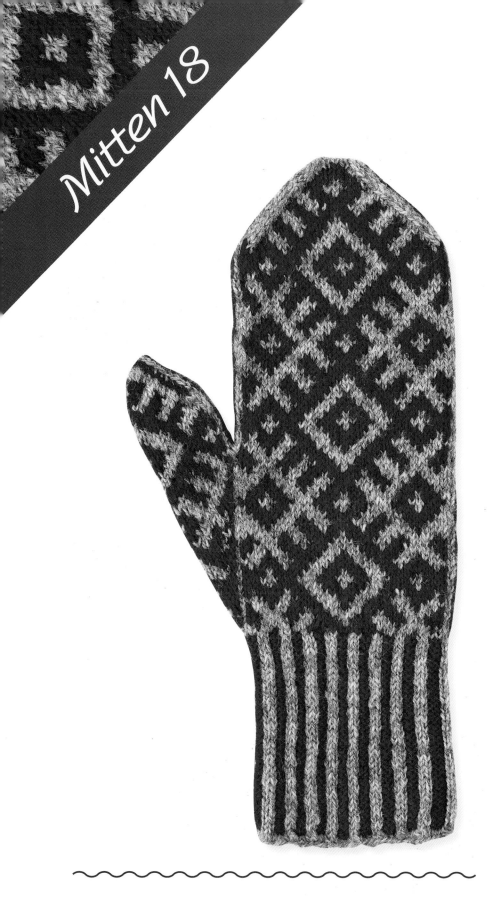

Skill Level

Intermediate ◼◼◼◻

Sizes

Adult's Medium (Large)

Yarn

Finullgarn 2-ply from Nordic Fiber Arts (100% wool; 50 g; 178 yds) (2)
MC: 1 skein in color Red
CC: 1 skein in color Light Gray

Needles

Set of 5 double-pointed needles in size 3 (3.25 mm) or size to obtain gauge

Gauge

16 sts and 18 rnds = 2" over two-color St st worked in the rnd

Reticulation

24 sts by 24 rnds

Instructions

Using CC, CO 64 (72) sts; join. Work cuff in corrugated ribbing (page 14) using CC (knit) and MC (purl) until cuff measures 3½ (3¾)".

Work hand and thumb, following chart, opposite.

Though it looks large, the reticulation at 24 stitches by 24 rounds is one of the smaller repeats, composed of two different elements.

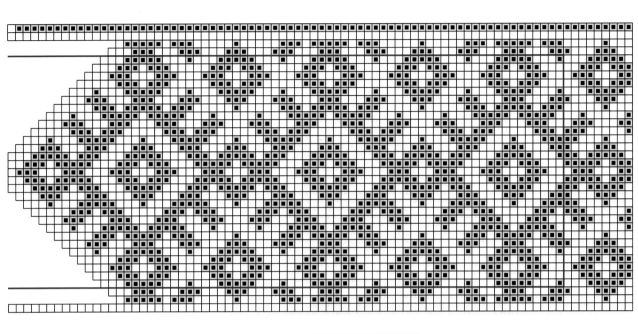

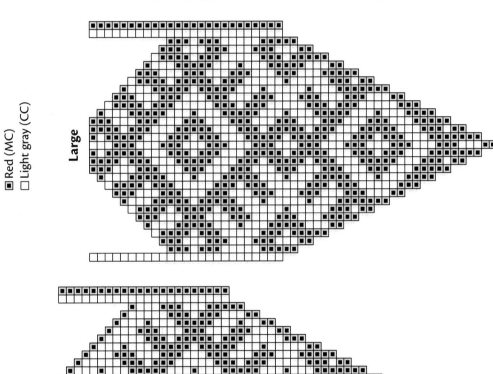

☑ Red (MC)
☐ Light gray (CC)

Large

Medium

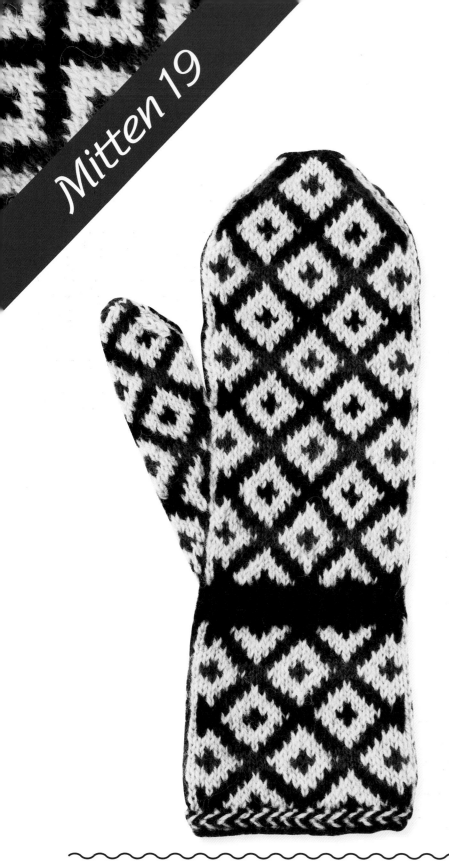

Skill Level

Intermediate ◼◼◼◻

Sizes

Child's Medium (Large)

Yarn

Finullgarn 2-ply from Nordic Fiber Arts (100% wool; 50 g; 178 yds) [2]
MC: 1 skein in color Light Yellow
CC1: 1 skein in color Bluish Violet
CC2: 1 skein in color Royal Blue
CC3: 1 skein in color Bluish Green

Needles

Set of 5 double-pointed needles in size 3 (3.25 mm) or size to obtain gauge

Gauge

16 sts and 18 rnds = 2" over two-color St st worked in the rnd

Reticulation

12 sts by 12 rnds

Instructions

Using MC and CC1, CO 48 (56) sts using twisted edge (see "Patterned Two-Color Cuffs" on page 14).

Work cuff from the chart, opposite, for 25 rows (until break in patt), then work ¾" of K2, P2 ribbing in CC1.

Work hand and thumb, following chart, opposite.

For this mitten, I used the light color as the background color, but you could also reverse the colors to make the background a series of dark stripes. You'll find this 12-stitch-by-12-round reticulation is one of the easier ones to work.

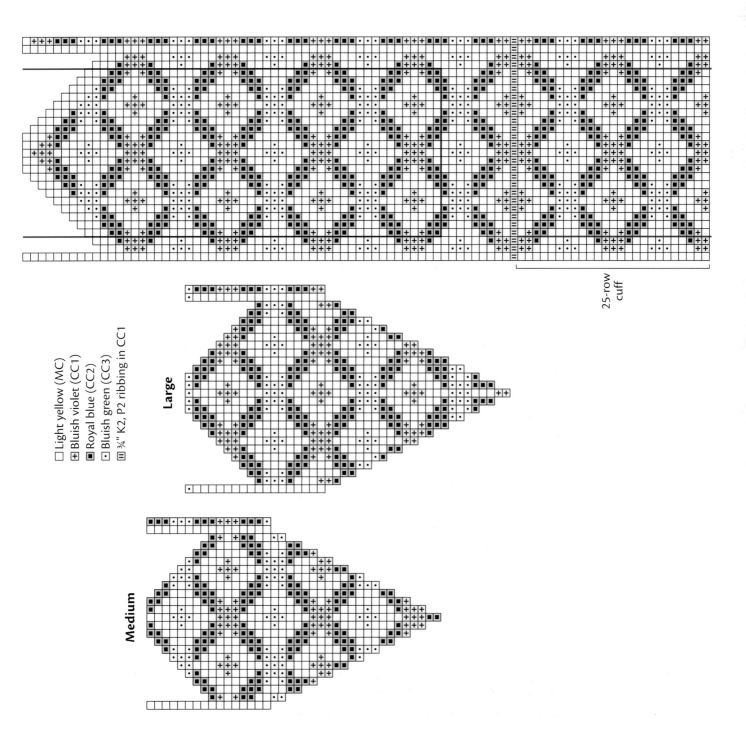

25-row cuff

□ Light yellow (MC)
⊞ Bluish violet (CC1)
■ Royal blue (CC2)
⊡ Bluish green (CC3)
⊟ ¾" K2, P2 ribbing in CC1

Large

Medium

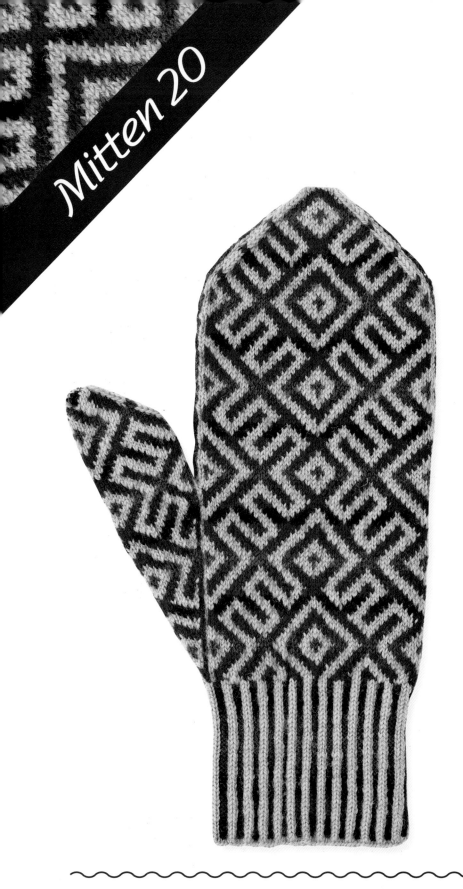

Skill Level

Experienced ■■■□

Sizes

Adult's Medium (Large)

Yarn

Brown Sheep Nature Spun Fingering (100% wool; 50 g; 310 yds) (1)
MC: 1 skein in color Light Sage Green
CC1: 1 skein in color Dark Purple
CC2: 1 skein in color Medium Purple
CC3: 1 skein in color Dark Rose
CC4: 1 skein in color Light Purple

Needles

Set of 5 double-pointed needles in size 1 (2.25 mm) or size to obtain gauge

Gauge

20 sts and 22 rnds = 2" over two-color St st worked in the rnd

Reticulation

48 sts by 72 rnds

Instructions

Using MC, CO 80 (92) sts; join. Work corrugated ribbing (page 14), using MC (knit) and CC1 (purl) and working 3-rnd stripes of each CC yarn until cuff measures 3½ (3¾)".

Work hand and thumb, following chart, opposite.

One major difference in this pattern is the longer length of the lines or hooks from the diamonds that give it a look similar to patterns of the North American Eskimos.

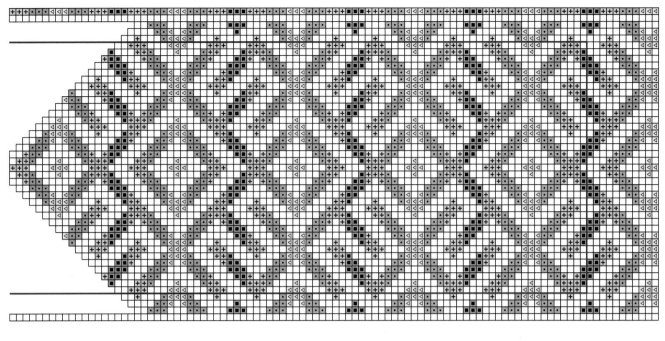

Large

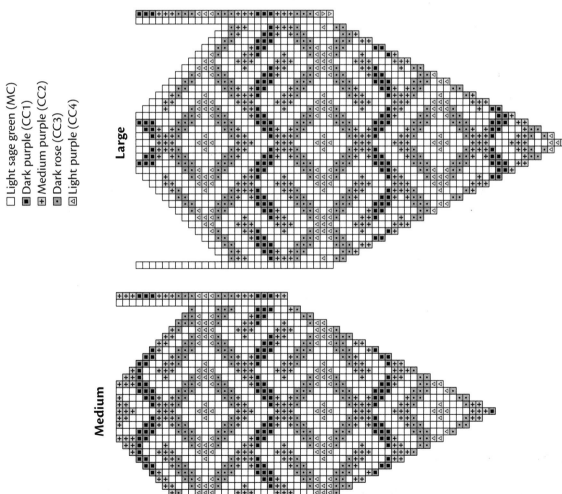

Medium

☐ Light sage green (MC)
■ Dark purple (CC1)
⊞ Medium purple (CC2)
▨ Dark rose (CC3)
◁ Light purple (CC4)

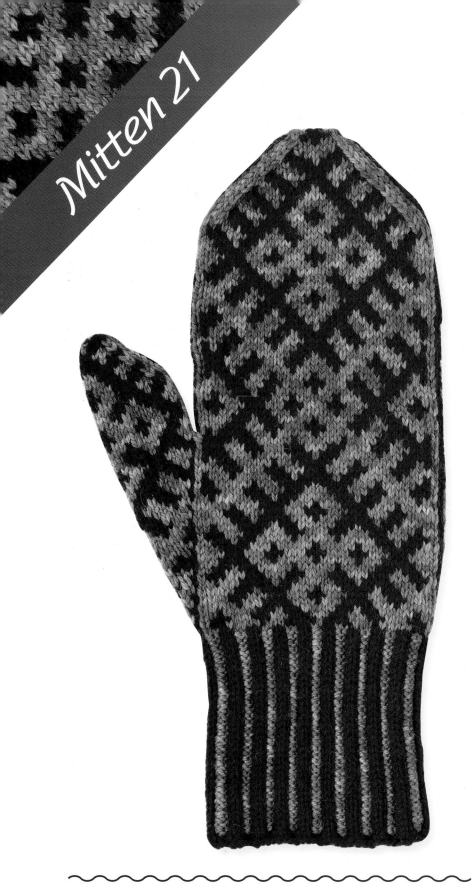

Skill Level

Intermediate ◼◼◼◻

Size

Adult's Medium (Large)

Yarn

MC: 1 skein of Nature Spun Sport from Brown Sheep Company, Inc. (100% wool; 50 g; 184 yds) in color Burgundy ②
CC: 1 skein of hand-painted sport-weight yarn (100% wool; 50 g; 184 yds) in color Rose/gray/green variegated ②

Needles

Set of 5 double-pointed needles in size 2 (2.75 mm) or size to obtain gauge.

Gauge

16 sts and 18 rnds = 2" over two-color St st worked in the rnd

Reticulation

42 sts by 42 rnds

Instructions

Using MC, CO 64 (72) sts; join. Work corrugated ribbing (page 14) using MC (knit) and CC (purl) until cuff measures 3½ (3¾)".

Work hand and thumb, following chart, opposite.

Another pleasing star-type pattern, this time knit with one solid-colored yarn and a subtly variegated hand-painted yarn.

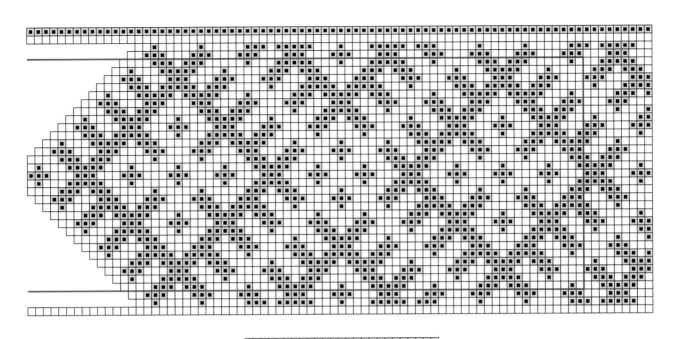

Large

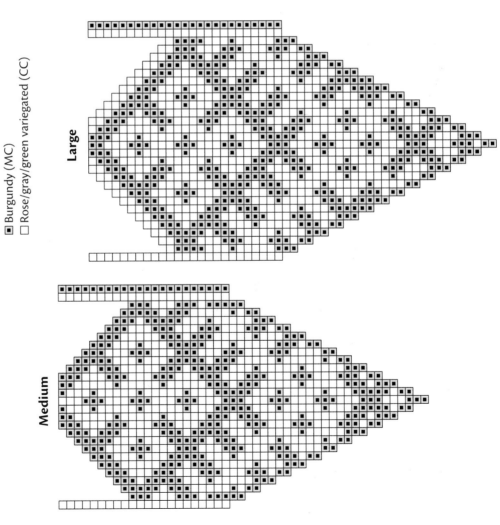

■ Burgundy (MC)
□ Rose/gray/green variegated (CC)

Medium

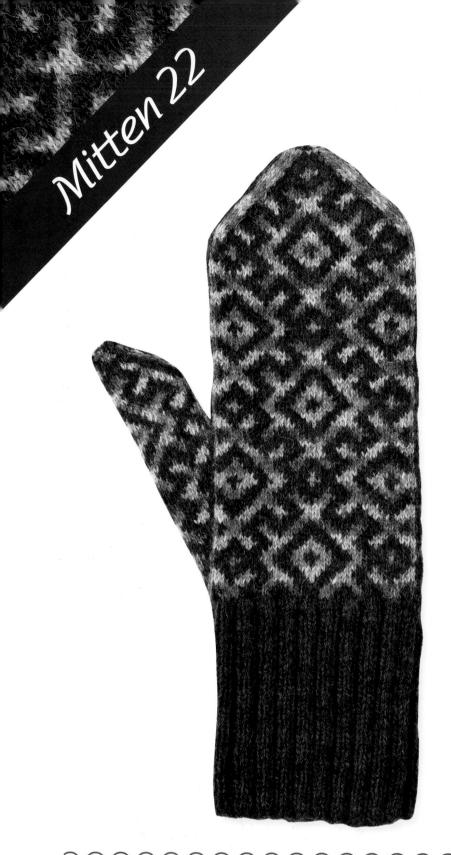

Skill Level

Experienced ◼◼◼▶

Sizes

Adult's Medium (Large)

Yarn

New England Shetland from Harrisville Designs (100% wool; 50 g; 217 yds) 🔳**1**
MC: 2 skeins in color Cobalt
CC1: 1 skein in color Cornflower
CC2: 1 skein in color Periwinkle
CC3: 1 skein in color Lilac
CC4: 1 skein in color Light Pink

Needles

Set of 5 double-pointed needles in size 0 (2 mm) or size to obtain gauge

Gauge

20 sts and 22 rnds = 2" over two-color St st worked in the rnd

Reticulation

30 sts by 30 rnds

Instructions

Using MC, CO 8 0 (92) sts; join. Work in K2, P2 ribbing until cuff measures 3½ (3¾)".

Work hand and thumb, following chart, opposite.

The hooks around the diamonds have been connected in a zigzag pattern. This creates a very different look from the other mittens in this pattern group, although it's somewhat similar to Mitten 24.

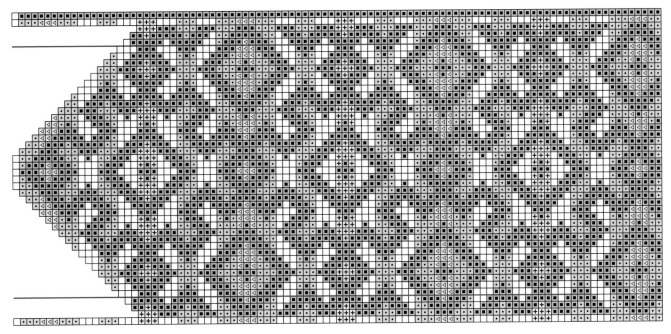

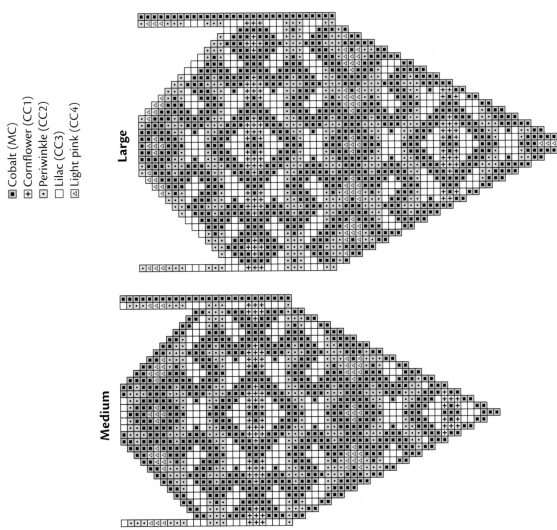

Large

Medium

■ Cobalt (MC)
+ Cornflower (CC1)
• Periwinkle (CC2)
☐ Lilac (CC3)
◁ Light pink (CC4)

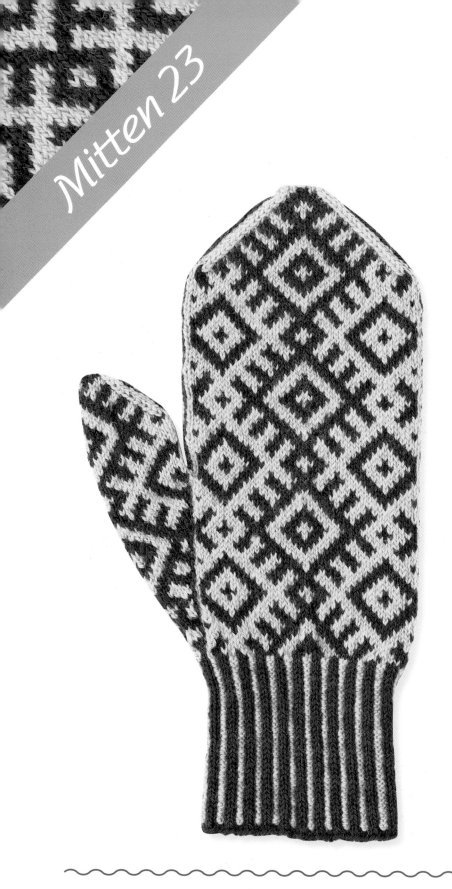

Skill Level

Intermediate ◼◼◼◻

Sizes

Adult's Medium (Large)

Yarn

Helmi Vuorelma Oy Satakieli 2-ply
(100% wool; 100 g; 357 yds) 🧶**1**
MC: 1 skein in color Green
CC: 1 skein in color Yellow

Needles

Set of 5 double-pointed needles
in size 0 (2 mm) or size to obtain
gauge

Gauge

20 sts and 22 rnds = 2" over two-
color St st worked in the rnd

Reticulation

30 sts by 24 rnds

Instructions

Using MC, CO 80 (92) sts; join.
Work corrugated ribbing (page 14)
using MC (knit) and CC (purl) until
cuff measures 3½ (3¾)".

Work hand and thumb, following
chart, opposite.

*This is truly a balanced design. The reticulation is dark on light
at the mitten's center, while being light on dark at the sides.*

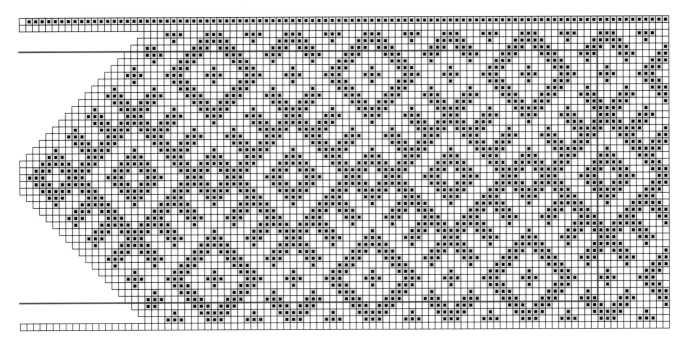

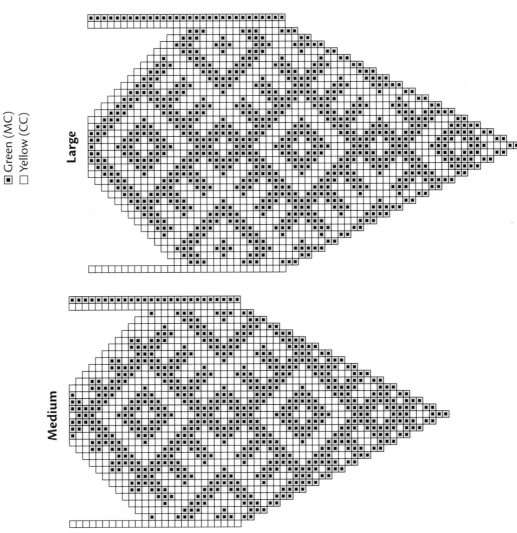

☐ Green (MC)
☐ Yellow (CC)

Large

Medium

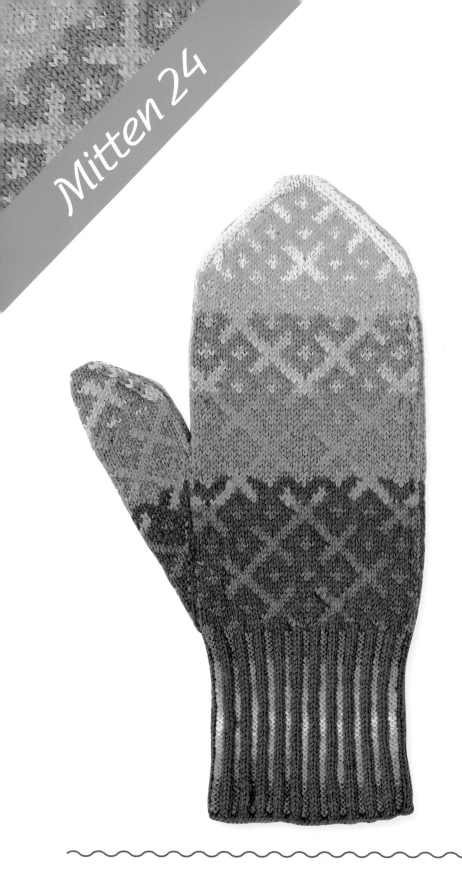

The individual diagonal lines with connecting ends create a serpentine appearance that gives a more rounded look to the overall pattern. The reticulation is another one with the star as central motif.

Skill Level

Experienced ◼◼◼◻

Sizes

Adult's Medium (Large)

Yarn

Nature Spun Fingering from Brown Sheep Company, Inc. (100% wool; 50 g; 310 yds) **1**
MC1: 1 skein in color Dark Turquoise
MC2: 1 skein in color Medium Turquoise
MC3: 1 skein in color Light Turquoise
CC1: 1 skein in color Dark Gold
CC2: 1 skein in color Medium Gold
CC3: 1 skein in color Light Gold
CC4: 1 skein in color Cream

Needles

Set of 5 double-pointed needles in size 1 (2.25 mm) or size to obtain gauge

Gauge

20 sts and 22 rnds = 2" over two-color St st worked in the rnd

Reticulation

36 sts by 48 rnds

Instructions

Using MC1, CO 80 (92) sts; join. Work corrugated ribbing (page 14) using MC1 (knit) and CC (purl) working CC colors as follows until cuff measures 3½ (4)".

6 (6) rnds CC1
6 (6) rnds CC2
5 (6) rnds CC3
5 (5) rnds CC4
5 (6) rnds CC3
6 (6) rnds CC2
6 (6) rnds CC1

Work hand and thumb, following chart, opposite.

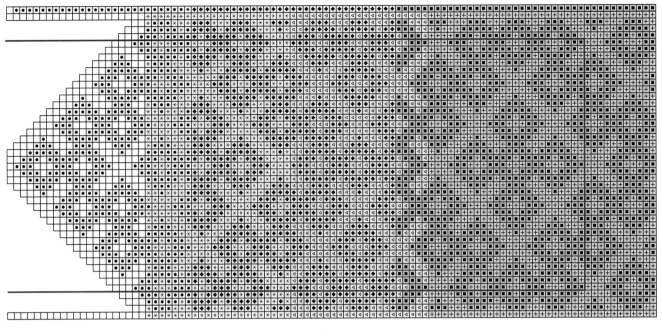

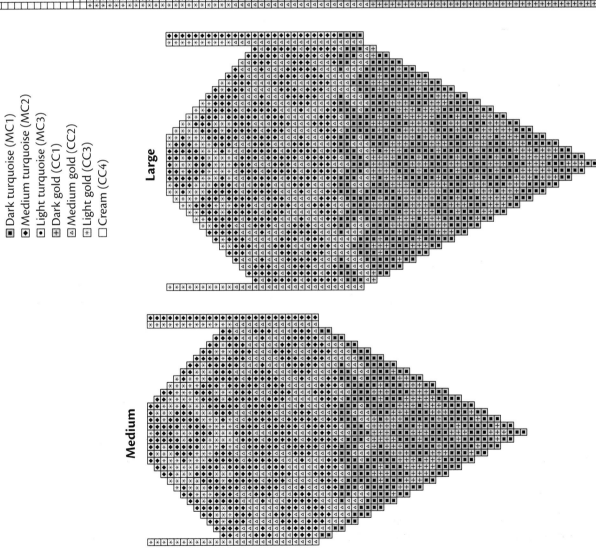

Dark turquoise (MC1)
Medium turquoise (MC2)
Light turquoise (MC3)
Dark gold (CC1)
Medium gold (CC2)
Light gold (CC3)
Cream (CC4)

Large

Medium

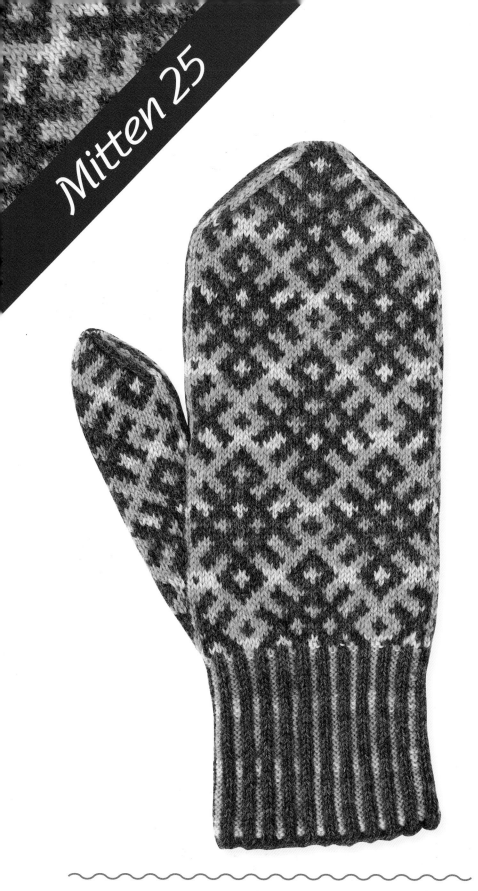

Skill Level

Experienced ■■■■

Size

Adult's Medium (Large)

Yarn

Nature Spun Fingering from Brown Sheep Company, Inc. (100% wool; 50 g; 310 yds) ⓵

MC: 1 skein in color Brown
CC1: 1 skein in color Light Turquoise
CC2: 1 skein in color Medium Turquoise
CC3: 1 skein in color Light Grayish Green

Needles

Set of 5 double-pointed needles in size 1 (2.25 mm) or size to obtain gauge

Gauge

20 sts and 22 rnds = 2" over two-color St st worked in the rnd

Reticulation

24 sts by 36 rnds

Instructions

Using MC, CO 80 (92); join. Work corrugated ribbing (page 14) using MC (knit) and CC (purl), repeating 3-rnd stripes of CC1, CC2, CC3, CC2 until the cuff measures 3½ (3¾)".

Work hand and thumb, following chart, opposite.

This mitten pattern is an isolated motif, which is a change from the connected reticulations. If you look carefully, you'll see the border pattern used in Mitten 13.

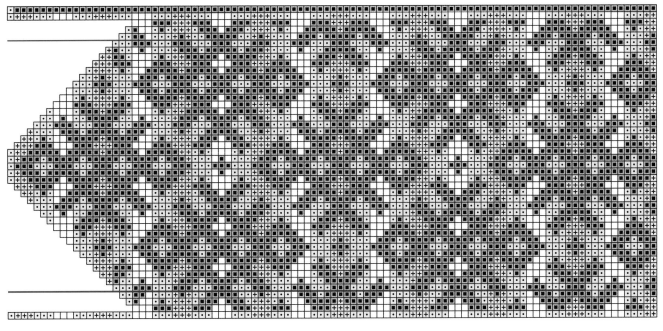

■ Brown (MC)
□ Light turquoise (CC1)
· Medium turquoise (CC2)
+ Light grayish green (CC3)

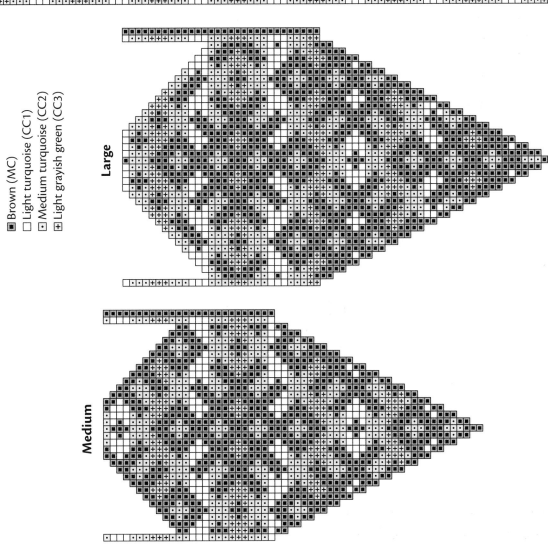

Large

Medium

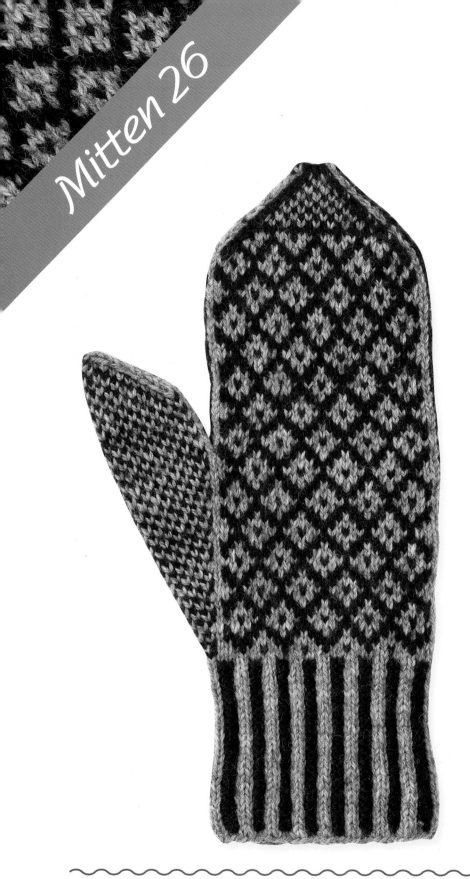

Skill Level

Intermediate ◼◼◼◻

Sizes

Adult's Medium (Large)

Yarn

Nature Spun Sport from Brown Sheep Company, Inc. (100% wool; 50 g; 184 yds) (**2**)

MC: 1 skein in color Medium Olive Green

CC: 1 skein in color Light Heather Gray

Needles

Set of 5 double-pointed needles in size 2 (2.75 mm) or size to obtain gauge.

Gauge

16 sts and 18 rnds = 2" over two-color St st worked in the rnd

Reticulation

6 sts by 8 rnds

Instructions

Using CC, CO 64 (72) sts; join. Work corrugated ribbing (page 14) using CC (knit) and MC (purl) until cuff measures 3½ (3¾)".

Work hand and thumb, following chart, opposite.

Reminiscent of Scandinavian knitting, this simple reticulation is highlighted by a 2-stitch-by-2-round checkerboard for the thumb and tip.

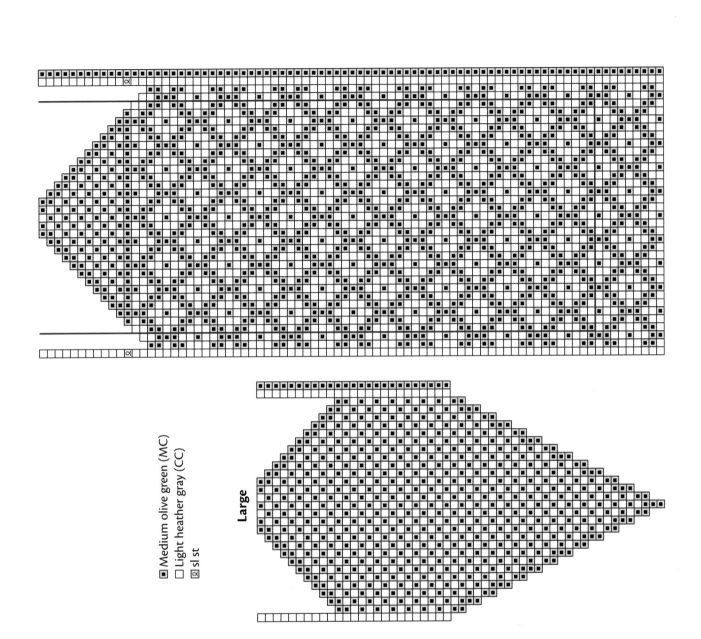

Medium olive green (MC)
Light heather gray (CC)
sl st

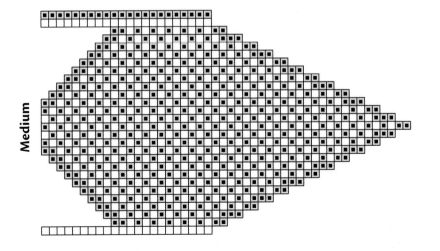

Medium

Large

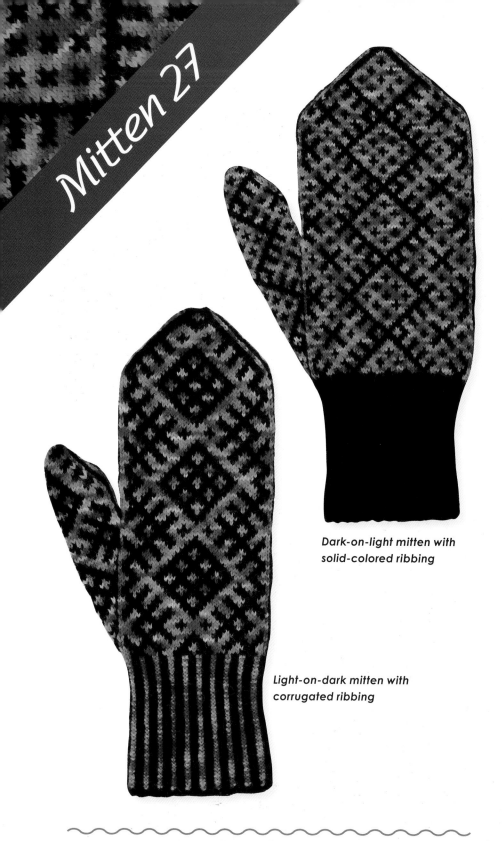

Dark-on-light mitten with solid-colored ribbing

Light-on-dark mitten with corrugated ribbing

Skill Level

Experienced ████

Size

Adult's Medium (Large)

Yarn

MC: 1 skein of Nature Spun Fingering from Brown Sheep Company, Inc. (100% wool; 50 g; 310 yds) color Black (**1**)
CC: 1 skein of hand-painted fingering-weight yarn (100% wool; 50 g; 310 yds) color Red/Gold/Orange variegated (**1**)

Needles

Set of 5 double-pointed needles in size 1 (2.25 mm) or size to obtain gauge

Gauge

20 sts and 22 rnds = 2" over two-color St st worked in the rnd

Reticulation

36 sts by 24 rnds

Instructions

Using MC, CO 80 (92) sts; join. For two-color cuff, work corrugated ribbing (page 14) with MC (knit) and CC (purl) until cuff measures 3½ (3¾)". For solid-color cuff, work K2, P2 ribbing with MC.

For light-on-dark version, work hand and thumb, following chart, opposite.

For dark-on-light version, work chart but reverse colors.

As you can see, the pattern looks quite different when worked light on dark than it does when worked dark on light. The pattern is unusual in that it combines two elements that aren't commonly used, the diamond with nine crosses and a cross placed at the center of the other element.

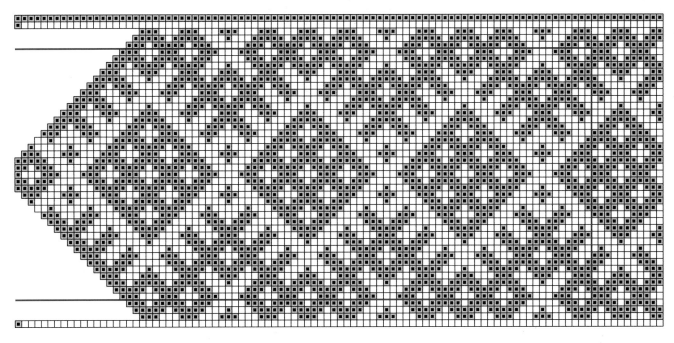

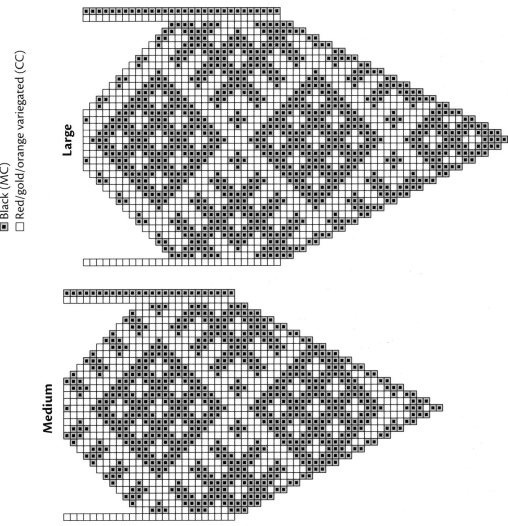

☒ Black (MC)
☐ Red/gold/orange variegated (CC)

Large

Medium

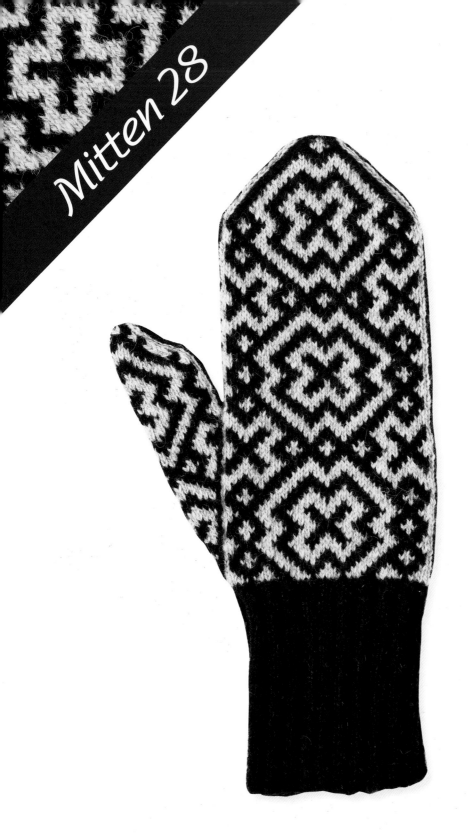

Skill Level

Intermediate ◼◼◼◻

Sizes

Adult's Medium (Large)

Yarn

New England Shetland from Harrisville Designs (100% wool; 50 g; 217 yds) [1]
MC: 2 skeins in color Blackberry
CC: 1 skein in color Light Gray

Needles

Set of 5 double-pointed needles in size 0 (2 mm) or size to obtain gauge

Gauge

20 sts and 22 rnds = 2" over two-color St st worked in the rnd

Reticulation

30 sts by 30 rnds

Instructions

Using MC, CO 80 (92) sts; join. Work K2, P2 ribbing until cuff measures 3½ (3¾)".

Work hand and thumb, following chart, opposite.

I designed this reticulation following a combination of rules for patterning. By starting with a four-row-wide border with a 30-stitch repeat, I was able to create this interesting design.

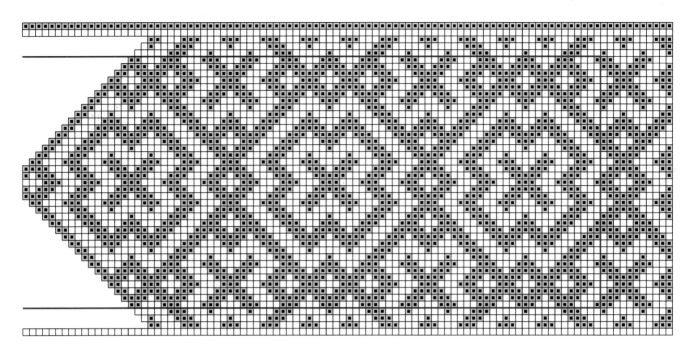

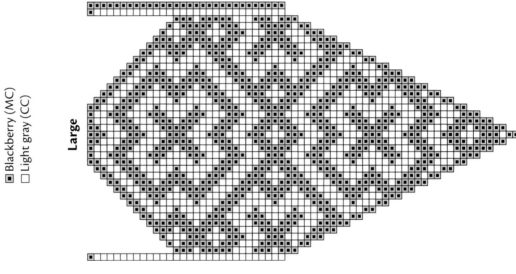

■ Blackberry (MC)
☐ Light gray (CC)

Large

Medium

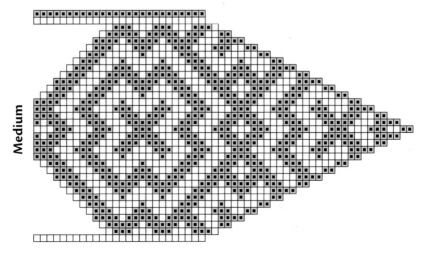

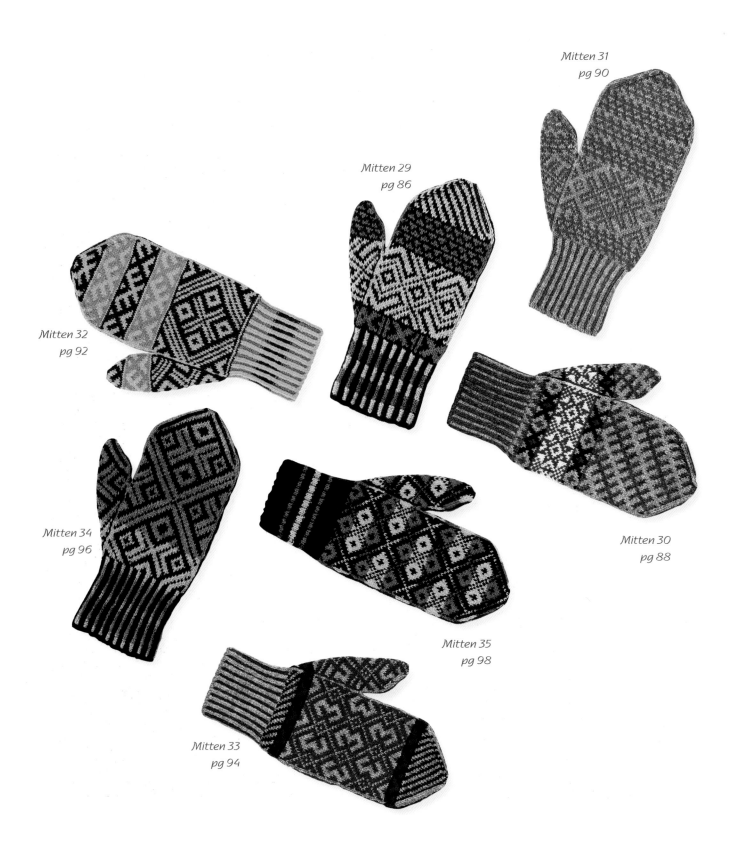

Mitten 31
pg 90

Mitten 29
pg 86

Mitten 32
pg 92

Mitten 34
pg 96

Mitten 35
pg 98

Mitten 30
pg 88

Mitten 33
pg 94

Complex Borders and Complex Reticulations

These patterns seem to have been developed later by more skillful knitters who could either remember more complicated patterns or had the use of pencil and paper for charting. They are expansions of the 3-by-3 reticulation into a 2, 1, 2; 3, 1, 3; or 2, 1, 1, 1, 2 pattern. In the chart showing the pattern examples, opposite, (a) from Mitten 34 varies more than those used for borders, such as (b) from Mitten 31, which is a variation of (c); (d) shows one horizontal repeat of the pattern in Mitten 33; and (e) shows the border used in Mitten 14.

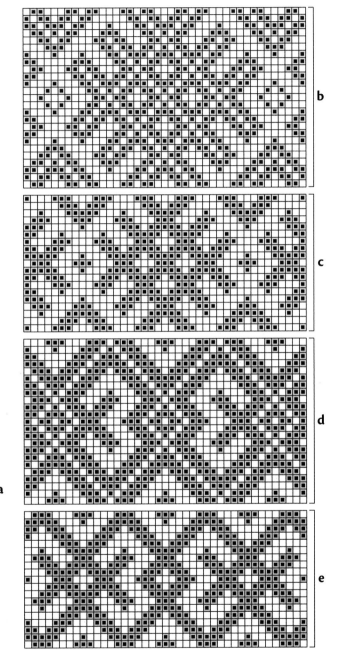

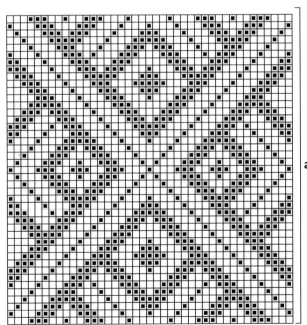

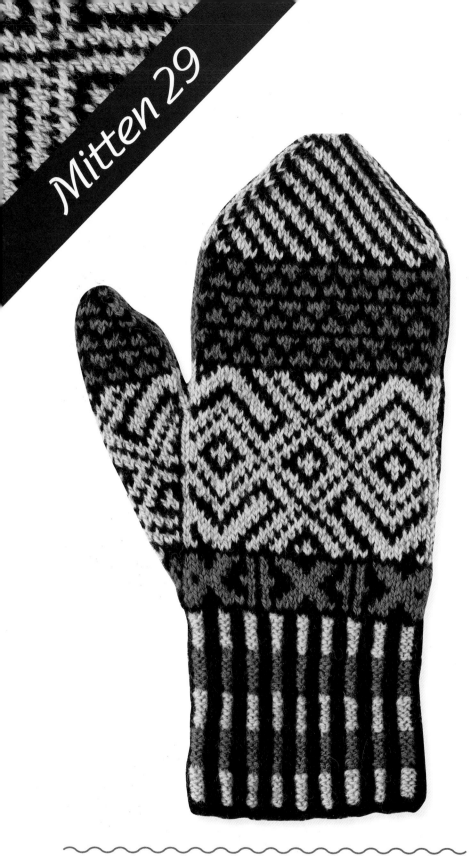

Skill Level

Experienced ◼◼◼◻

Size

Adult's Medium (Large)

Yarn

Finullgarn 2-ply from Nordic Fiber Arts (100% wool; 50 g; 178 yds) **2**

MC: 2 skeins in color Dark Green
CC1: 1 skein in color Rose
CC2: 1 skein in color Gold

Needles

Set of 5 double-pointed needles in size 3 (3.25 mm) or size to obtain gauge

Gauge

16 sts and 18 rnds = 2" over two-color St st worked in the rnd

Reticulation

24 rnd-wide main border

Instructions

Using MC, CO 64 (72) sts; join. Work corrugated ribbing (page 14) using MC (knit) and alternating CC1 and CC2 (purl) in 7-rnd stripes until cuff measures 3½ (3¾)".

Work hand and thumb, following chart, opposite.

This mitten is designed with sophisticated Komi patterns: the main border and the X-style septenary border at the wrist. The hand portion of the mitten has two patterns, each with four-stitch repeats.

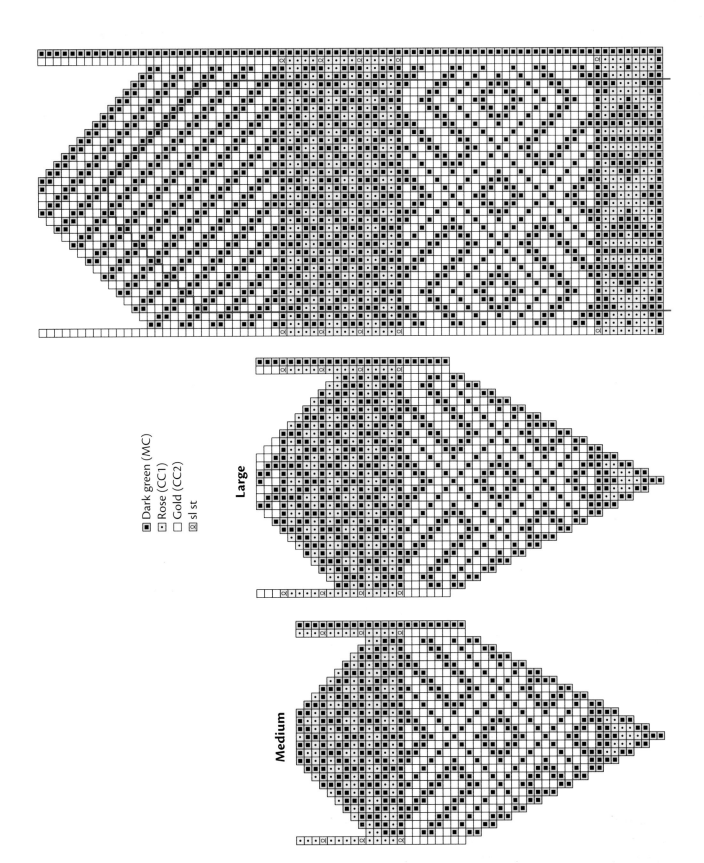

Dark green (MC)
Rose (CC1)
Gold (CC2)
sl st

Large

Medium

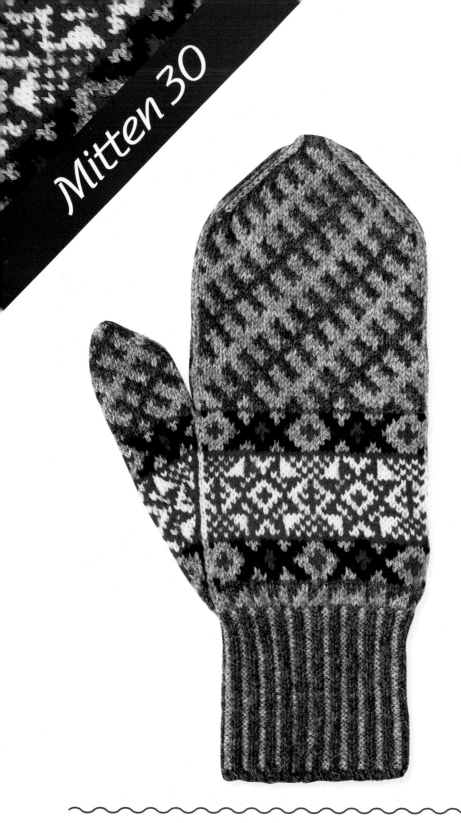

Skill Level

Experienced ■■■□

Size

Adult's Medium (Large)

Yarn

Nature Spun Fingering from Brown Sheep Company, Inc. (100% wool; 50 g; 310 yds) **1**

MC: 1 skein in color Dark Gray
CC1: 1 skein in color Light Heather Gray
CC2: 1 skein in color Black
CC3: 1 skein in color Red
CC4: 1 skein in color White

Needles

Set of 5 double-pointed needles in size 1 (2.25 mm) or size to obtain gauge

Gauge

20 sts and 22 rnds = 2" over two-color St st worked in the rnd

Instructions

Using MC, CO 80 (92) sts; join. Work corrugated ribbing (page 14) using MC (knit) and CC1 (purl) until cuff measures 3½ (3¾)".

Work hand and thumb, following chart, opposite.

The border of this mitten is a version of a star pattern (commonly found in Scandinavian knitting), which is said to have been brought to the Komi from Russian women who immigrated to the area. The design also includes a septenary border, a simple reticulation over the fingers, and a four-stitch repeat at the wrist.

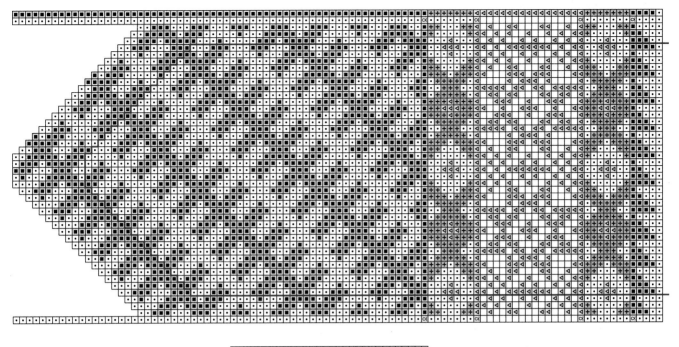

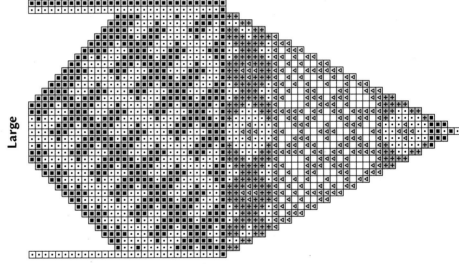

Large

Dark gray (MC)
Light heather gray (CC1)
Black (CC2)
Red (CC3)
White (CC4)
sl st

Medium

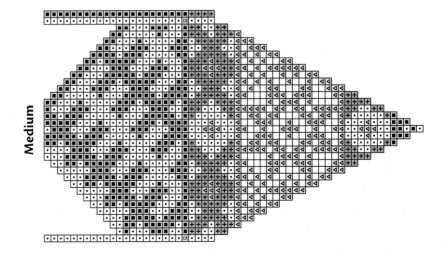

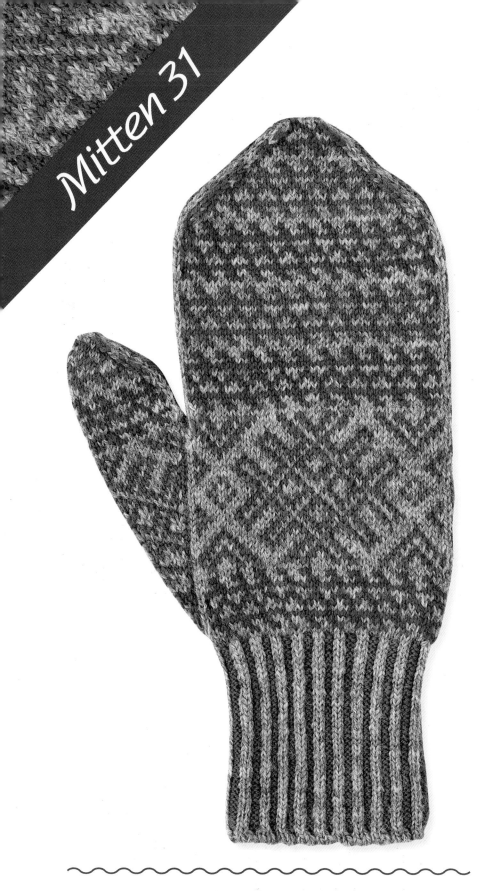

Skill Level

Experienced ◼◼◼◻

Sizes

Adult's Medium (Large)

Yarn

Nature Spun Fingering from Brown Sheep Company, Inc. (100% wool; 50 g; 310 yds) 🔘 **1**
MC: 1 skein in color Gray Heather
CC1: 1 skein in color Pink
CC2: 1 skein in color Turquoise

Needles

Set of 5 double-pointed needles in size 1 (2.25 mm) or size to obtain gauge

Gauge

20 sts and 22 rnds = 2" over two-color St st worked in the rnd

Reticulation

32 sts by 32 rnds

Instructions

Using MC, CO 80 (92) sts; join. Work corrugated ribbing (page 14) using MC (knit) and CC1 (purl) until cuff measures 3½ (3¾)".

Work hand and thumb, following chart, opposite.

The wide border in this design is an expansion of the popular three lines crossing. It also uses a stacked four-stitch pattern of diagonal lines with a zigzag.

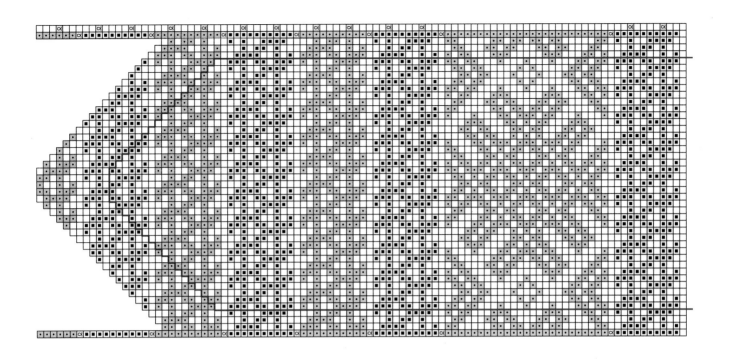

□ Gray heather (MC)
⊡ Pink (CC1)
■ Turquoise (CC2)
⊠ sl st

Large

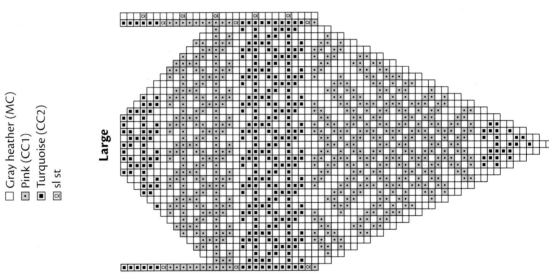

Medium

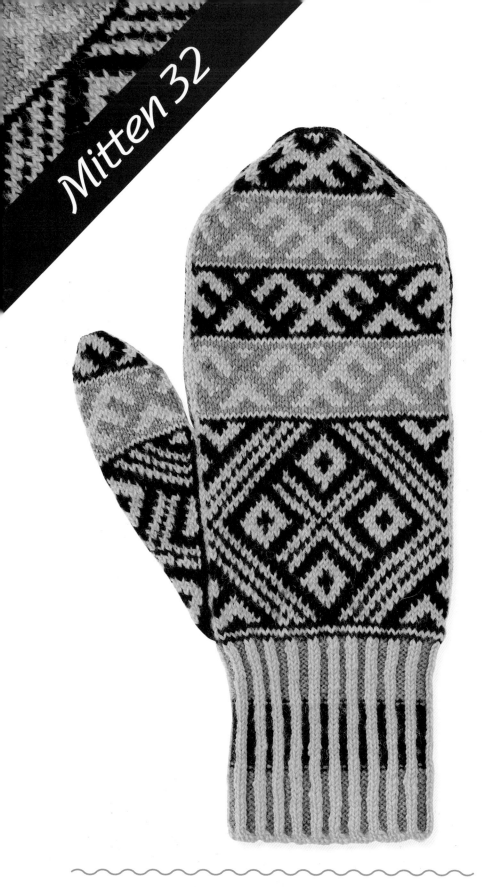

Skill Level

Experienced ■■■□

Sizes

Adult's Medium (Large)

Yarn

Nature Spun Fingering from Brown Sheep Company, Inc. (100% wool; 50 g; 310 yds) 【1】
MC: 1 skein in color Gold
CC1: 1 skein in color Purple
CC2: 1 skein in color Green

Needles

Set of 5 double-pointed needles in size 1 (2.25 mm) or size to obtain gauge

Gauge

20 sts and 22 rnds = 2" over two-color St st worked in the rnd

Instructions

Using MC, CO 80 (92) sts; join. Work corrugated ribbing (page 14) using MC (knit) and CC (purl), alternating CC1 and CC2 in 12-rnd stripes until cuff measures 3½ (3¾)". Then work 1 rnd of purple and 1 rnd of gold.

Work hand and thumb, following chart, opposite.

With one complex border and a 10-round border related to the three lines crossing, this mitten uses a very popular pattern for combining borders and reticulations.

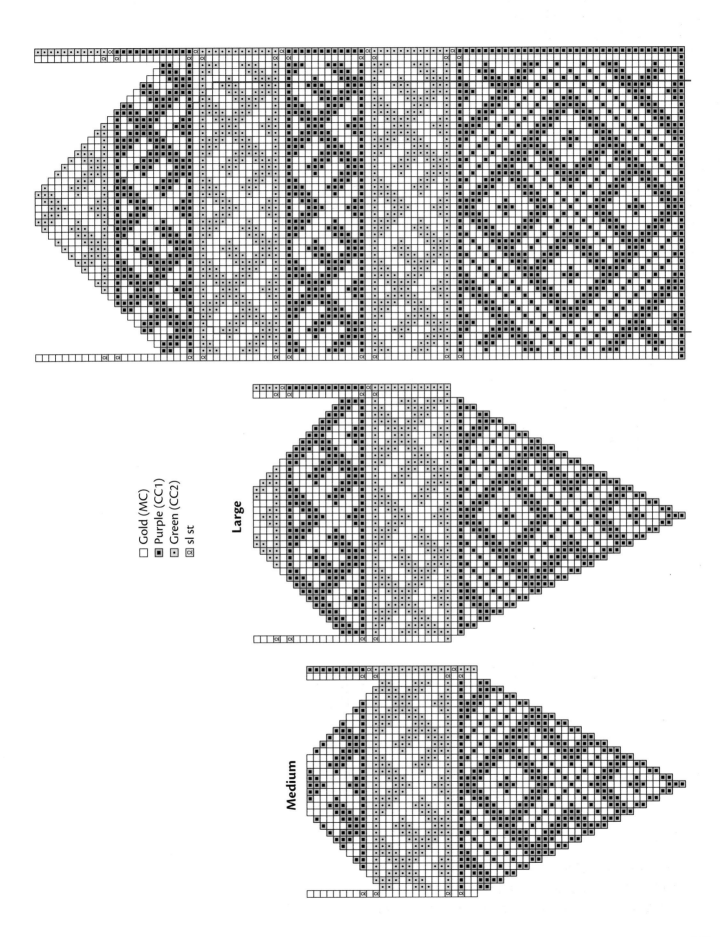

Large

Medium

☐ Gold (MC)
■ Purple (CC1)
⊡ Green (CC2)
⊠ sl st

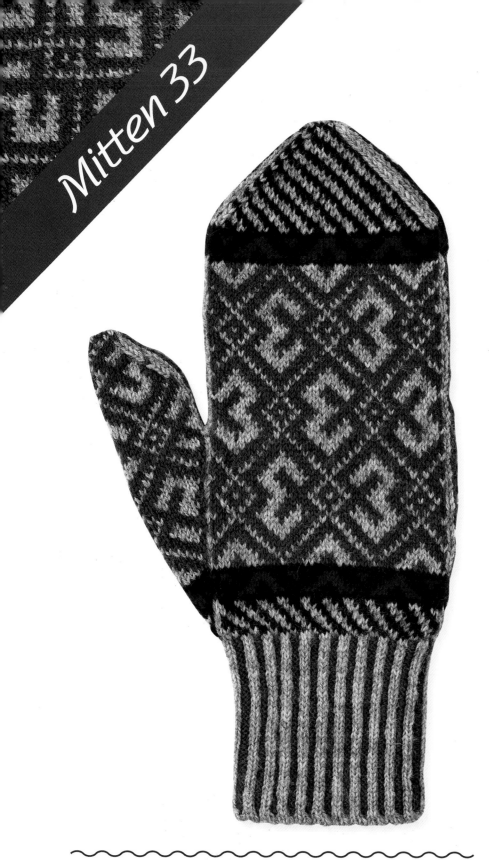

Skill Level

Experienced ◼◼◼◻

Sizes

Adult's Medium (Large)

Yarn

Nature Spun Fingering from Brown Sheep Company, Inc. (100% wool; 50 g; 310 yds) ▣

MC: 1 skein in color Light Gray Heather

CC1: 1 skein in color Medium Blue

CC2: 1 skein in color Dark Blue

CC3: 1 skein in color Red

Needles

Set of 5 double-pointed needles in size 1 (2.25 mm) or size to obtain gauge

Gauge

20 sts and 22 rnds = 2" over two-color St st worked in the rnd

Reticulation

32 sts by 28 rnds

Instructions

Using MC, CO 80 (92) sts; join. Work corrugated ribbing (page 14), using MC (knit) and CC1 (purl) until cuff measures 3½ (3¾)".

Work hand and thumb, following chart, opposite.

If this pattern looks familiar, it's because it's an expansion of the wide-border belt pattern from Mitten 14. Also included in this design are a four-stitch diagonal and a four-round border.

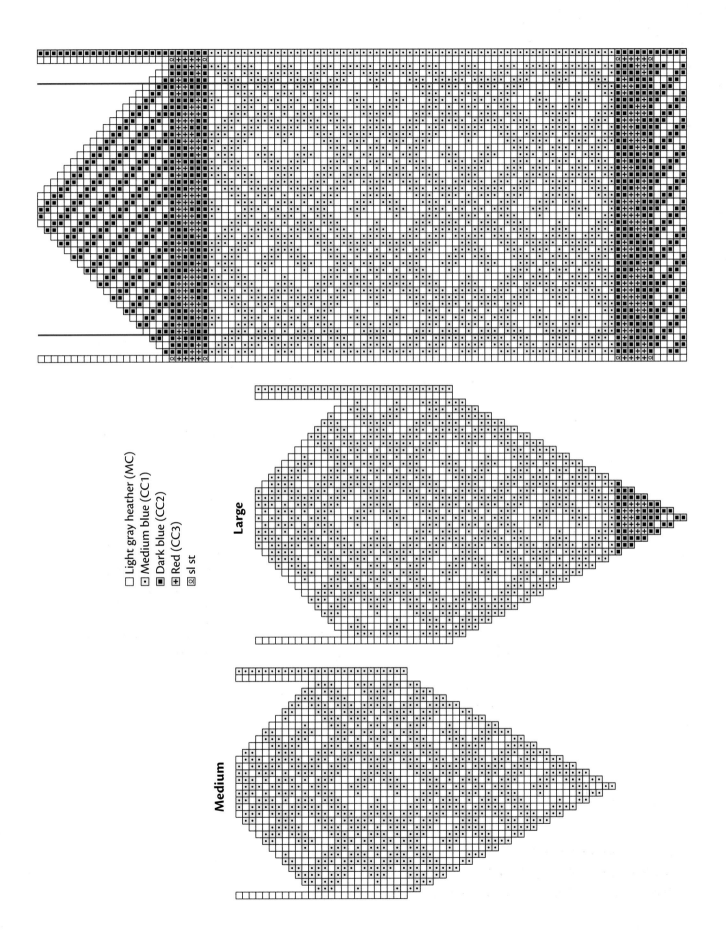

Light gray heather (MC)
Medium blue (CC1)
Dark blue (CC2)
Red (CC3)
sl st

Large

Medium

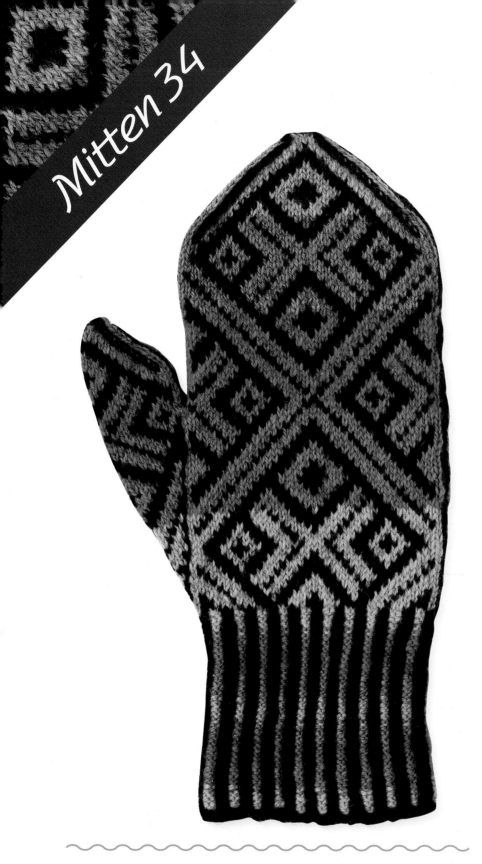

Skill Level

Experienced ■■■□

Size

Adult's Medium (Large)

Yarn

Finullgarn 2-ply from Nordic Fiber Arts (100% wool; 50 g; 178 yds) **2**
MC: 2 skeins in color Navy Blue
CC1: 1 skein in color Light Green
CC2: 1 skein in color Bluish Green
CC3: 1 skein in color Medium Blue
CC4: 1 skein in color Lavender
CC5: 1 skein in color Medium Pink

Needles

Set of 5 double-pointed needles in size 0 (2 mm) or size to obtain gauge

Gauge

20 sts and 22 rounds = 2" over two-color St st worked in the rnd

Reticulation

44 sts by 44 rnds

Instructions

Using MC, CO 80 (92) sts; join. Work corrugated ribbing (page 14) using MC (knit) and CC (purl), working 3 rnds of each CC beg with CC1 and progressing through CC5 and then back to CC1. Work until cuff measures 3½ (3¾)".

Work hand and thumb, following chart, opposite.

The asymmetrical nature of the diamond and the reticulation with one pattern repeated over both axes makes this a very interesting pattern.

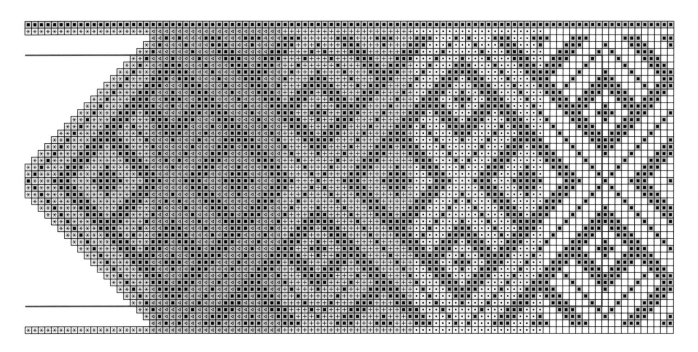

Large

Medium

■ Navy (MC)
▪ Light green (CC1)
☐ Bluish green (CC2)
· Medium blue (CC3)
+ Medium blue (CC3)
◁ Lavender (CC4)
✻ Medium pink (CC5)

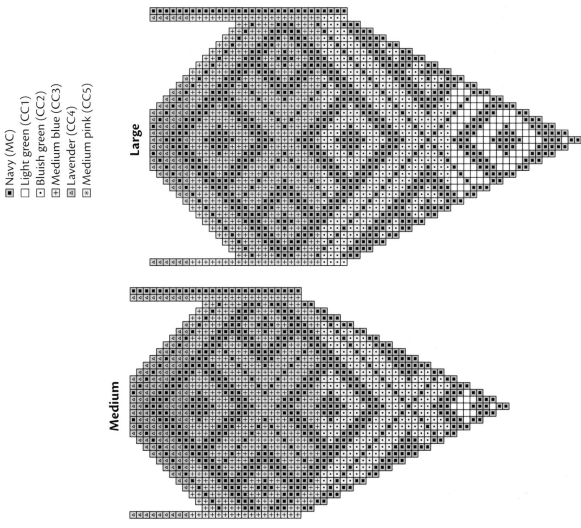

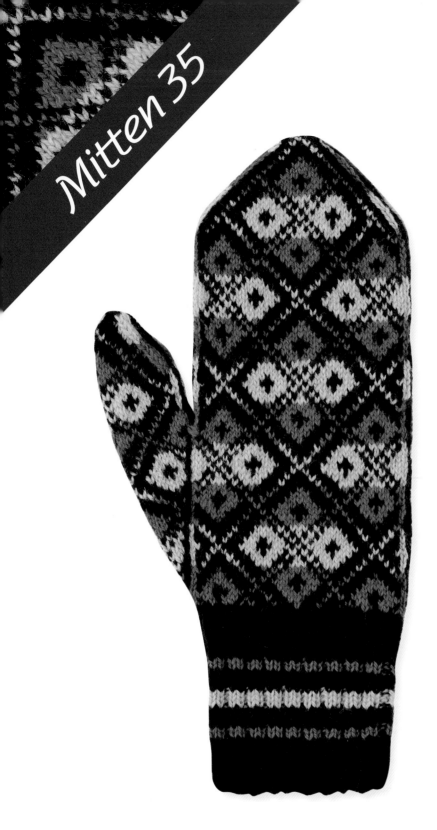

Skill Level

Experienced ◼◼◼◻

Sizes

Adult's Medium (Large)

Yarn

Finullgarn 2-ply from Nordic Fiber Arts (100% wool; 50 g; 178 yds) [2]
MC: 2 skeins in color Purple
CC1: 1 skein in color Lavender
CC2: 1 skein in color Gold

Needles

Set of 5 double-pointed needles in size 3 (3.25 mm) or size to obtain gauge

Gauge

16 sts and 18 rnds = 2" over two-color St st worked in the rnd

Reticulation

28 sts by 28 rnds

Instructions

Using MC, CO 64 (72) sts; join. Work K2, P2 ribbing in stripes as follows.

16 (18) rnds MC
2 rnds CC1
4 rnds MC
3 rnds CC2
4 rnds MC
2 rnds CC1
16 (18) rnds MC

Cuff should measure 3½ (3¾)".

Work hand and thumb, following chart, opposite.

A recent traveler to the Komi Republic showed me a pair of contemporary-knit mittens. This pattern is copied from that pair of mittens.

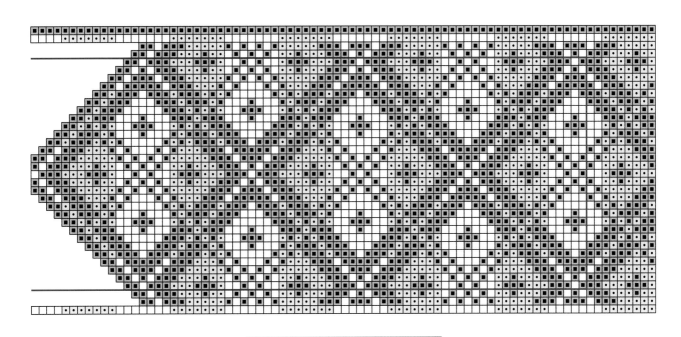

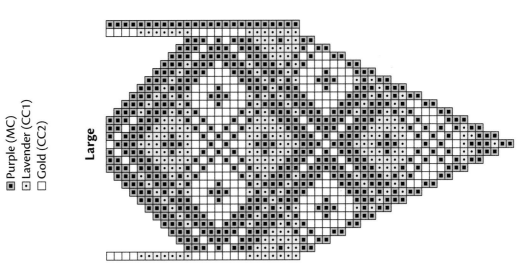

Large

■ Purple (MC)
⊡ Lavender (CC1)
□ Gold (CC2)

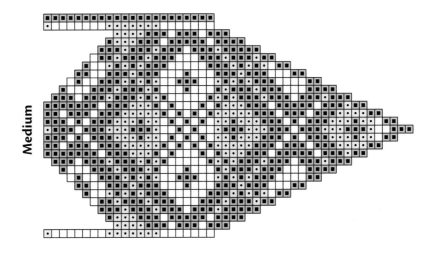

Medium

Alternative Ways of Working Mittens

While I prefer knitting mittens on double-pointed needles, some people have trouble managing them or drop stitches when working with double-pointed needles. Circular needles or knitting flat and seaming are two possible solutions to these difficulties.

Using Circular Needles

Using two 24" circular needles, arrange the stitches for the palm of the mitten on one needle (needle 1) and the stitches for the back of the hand on the other (needle 2). Using only needle 1, work all of the stitches for the palm and half of the stitches for the thumb. When you get to the middle of the thumb, drop both ends of needle 1, pick up the ends of needle 2, and continue knitting, working across the second half of the thumb stitches and then the back of the hand stitches. Note that the stitches on each needle do not make a circle; the stitches on both needles make the circle. Continue working around in this manner. Take care to not use one needle point from needle 1 and another needle point from needle 2 at the same time, or you'll inadvertently knit all the stitches onto one needle!

Knitting Flat and Sewing the Seam

Increase 1 stitch when casting on to make a seam stitch. For children's mittens cast on 49 (57) stitches; for adult's gauge of 8 stitches per inch, cast on 65 (73) stitches; and for adult's gauge of 10 stitches per inch, cast on 81 (93) stitches. In knitting the cuff pattern, duplicate the first and last stitches: if you're working K2, P2 ribbing, the first 2 stitches will be a K2 and the end of the row will be K2, P2, K2, P2, K1. The first and last knit sts will each provide ½ stitch for the seam, which will be invisible. When picking up stitches for the thumb, add one stitch for the seam at the inside of the thumb. Or, work the thumb in the round with double-pointed needles if you prefer.

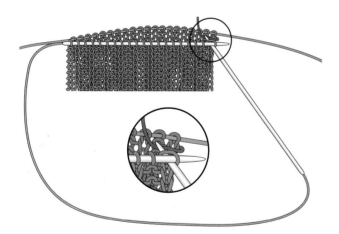

Caps

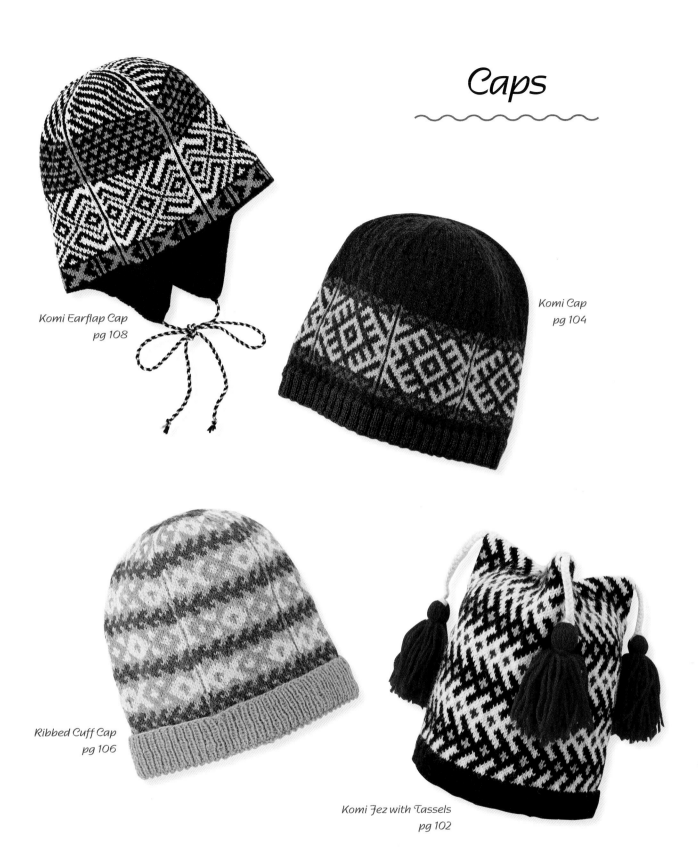

Komi Earflap Cap
pg 108

Komi Cap
pg 104

Ribbed Cuff Cap
pg 106

Komi Fez with Tassels
pg 102

Komi Fez with Tassels

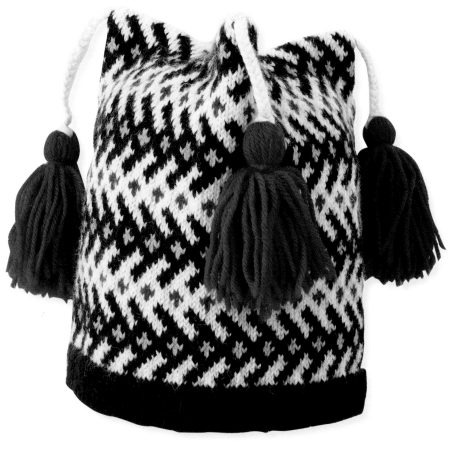

A fez is one of the simplest cap forms; it is just a tube of knitting that's knit to the proper size for a given head. This cap matches Mitten 16 on page 58.

Skill Level

Intermediate ◼◼◼◻

Sizes

Child's Medium (Child's Large, Adult's Medium, Adult's Large)

Finished circumference

Approx 16 (18, 20, 22)"

Yarn

Finullgarn 2-ply from Nordic Fiber Arts (100% wool; 50 g; 178 yds) ⓶

MC: 1 skein in color Blue
CC1: 1 skein in color White
CC2: 1 skein in color Red
CC3: 1 skein in color Gold

Needles

Size 3 (3.25 mm) circular needle (16" long) or size needed to give gauge.

Gauge

16 sts and 18 rnds = 2" over two-color St st worked in the rnd

Instructions

CO 126 (144, 162, 180) sts on circular needle; join, being careful not to twist sts. Beg K1, P1 ribbing; place marker at the end of first rnd.

Cont in K1, P1 ribbing for 1".

Work chart for 6 (7, 8, 9)" above the CO. BO loosely.

Sew points: Turn cap inside out to sew 3 points together. With a tapestry needle and piece of yarn about 24" long, move 21 (24, 27, 30) sts from the end of BO. Beg by sewing the 21st & 22nd [(24th & 25th), (27th & 28th), (30th & 31st)] sts together, working until you get back to beg of rnd. You now have one third of the cap sewn together (one point of three). Take the middle stitch of what is unsewn, and bring it beside the needle and

yarn. Work the 2nd point as the first. Break off the yarn. Return to the center and sew the 3rd point. Weave in all ends.

Tassel: Wind red yarn around a 4"-wide piece of cardboard 40 times. Cut 6 strands of white yarn 24" long. Place the strands through the yarn wound on the cardboard. Pull so the ends are even, then braid 3 sections of 4 strands each, (making a braid approx 5" long). Tie a knot in the end of the braid. Secure the end of the tassel about 1" from where the braid is attached by taking a piece of yarn and winding it around the tassel three times tightly. Make two more tassels. Cut the ends of the tassels. Attach the knotted end of each braid to each corner of the top of the cap.

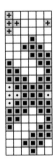

■ Blue (MC)
☐ White (CC1)
⊞ Red (CC2)
⊡ Gold (CC3)

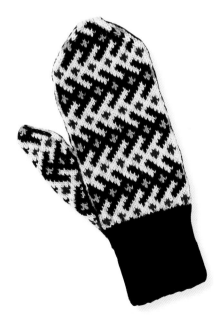

Adapting Mitten Patterns for a Fez

Select a pattern from the mitten charts, determine the repeat of the pattern, the finished size of the head, and the gauge you are knitting.

Below is a chart for guidance on hat sizing. It is better to have a cap 2" to 4" smaller than the head so that it stays snuggly on the head. It is also good to have a hat about 1" longer than the measurement from the nape of the neck to the top of the crown.

Size	Circumference	Height
Child's Medium	16"	6"
Child's Large	18"	7"
Adult's Medium	20"	8"
Adult's Large	22"	9"

To determine the number of stitches you'll need, multiply the head size by your gauge. You can adjust this total number of stitches slightly to accommodate complete pattern repeats. Then divide the number of stitches for the cap by the number of stitches in the repeat.

For example, let's use Mitten 15, and we'll work on a hat with a 20" circumference and an 8 stitches-to-the-inch gauge. First, multiply 20" by 8 stitches to the inch. This yields 160 stitches. Divide 160 by 24 stitches for the pattern repeat and you have 6.67. Since we don't want to do two-thirds of a repeat, we can knit six full repeats of the pattern over 144 stitches, which would measure 18" in circumference. Or, we could knit seven repeats over 168 stitches, which would make the hat 21" in circumference. It's up to you to determine which size is most appropriate. Or you may select another pattern with a different stitch count for your fez.

Komi Cap

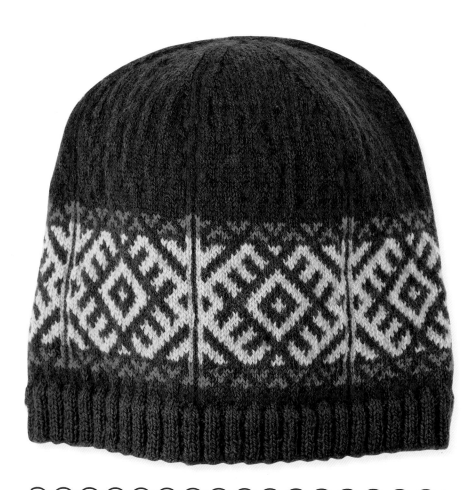

The main border for this cap was borrowed from Mitten 23. The cap is designed to have six identical panels separated by three seam stitches, as on the mittens. To complete the cap, a four-stitch border is topped with the basic pattern of the Komi stars.

Skill Level

Experienced ■■■■

Size:

Adult's Medium

Finished circumference

Approx 20"

Yarn

Helmi Vuorelma Oy Satakieli 2-ply (100% wool; 100 g; 357 yds) (**1**)
MC: 1 skein in color Green
CC1: 1 skein in color Yellow
CC2: 1 skein in color Orange
CC3: 1 skein in color Red

Needles

Size 0 (2 mm) circular needle (16" long) or size to obtain gauge
Set of 5 size 0 (2 mm) double-pointed needles

Gauge

10 sts and 11 rnds = 1" over two-color St st worked in the rnd

Instructions

Beg with cuff, CO 204 sts in MC on circular needle. Join, being careful not to twist, pm. Work K2, P2 ribbing for 1".
Beg chart at bottom right-hand corner, working 6 reps of patt around.

Crown (dec rnds): Work decs, beg on rnd 65 as follows: *Work first 3 seam sts, ssk, knit to within 2 sts of next seam line, K2tog, cont to work chart around. Work next rnd even*. Rep from * to * until rnd 92 is complete.

On rnd 93, work 3 seam sts, then work a double dec on last 3 sts of rep as follows: Sl 1-K2tog-psso.

On final rnd, work with MC only
and work double dec as on rnd 93
over first 3 sts, K1, cont to work
around. There should be 12 sts left.

Break off a tail of about 12". Thread
a tapestry needle and draw the end
through the rem sts, pulling it snug
and weaving into inside of cap.
Weave in all the ends.

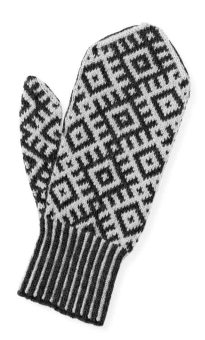

■ Green (MC)
□ Yellow (CC1)
⊡ Orange (CC2)
⊞ Red (CC3)
◩ sl st

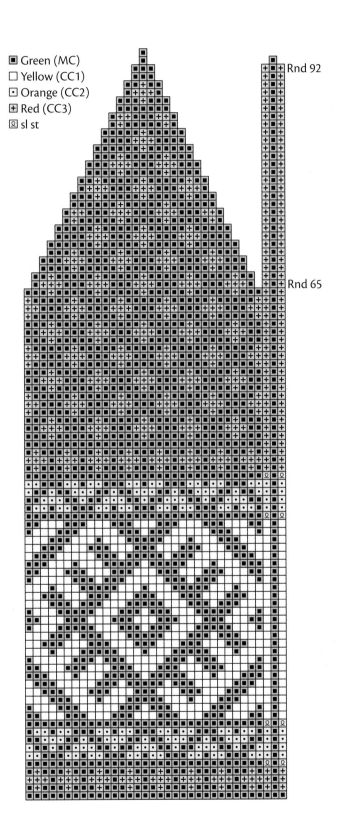

Rnd 92

Rnd 65

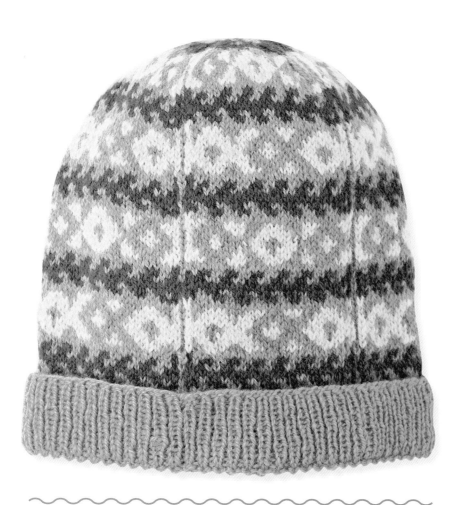

Skill Level

Experienced ◼◼◼▬

Sizes

Six sizes are provided for two
different gauges.
Child's Medium [CO 120 sts]
(Child's Large [140 sts], Adult's
Medium [160 sts], Adult's Large
[CO 180 sts])—in gauge of 8 sts to
1"; Adult's Medium [CO 200 sts],
Adult's Large [230 sts]—in gauge of
10 sts to 1")

 Note that the sample cap
pictured at left is for a Child's
Medium or Child's Large, with a
cast on of 120 or 140 sts. When
selecting a different chart, keep in
mind that the CO for a cap needs
to be 5 times the number of sts in
the hand chart.

Finished measurements

15 (17½, 20, 22½, 20, 23)"

Yarn

Finullgarn 2-ply from Nordic Fiber
Arts (100% wool; 50 g;
178 yds) [2]
MC: 1 skein in color Green
CC1: 1 skein in color Yellow
CC2: 1 skein in color Pink

Needles:

For gauge of 8 sts to 1":

 Size 2 (2.75 mm) circular
 needle (16" long)
 Size 3 (3.25 mm) circular
 needle (16" long) or size
 required for gauge
 Set of 5 size 3 (3.25 mm)
 double-pointed needles
For gauge of 10 sts to 1":
 Size 0 (2.0 mm) circular needle
 (16" long)
 Size 1 (2.25 mm) circular
 needle (16" long) or size
 required for gauge
 Set of 5 size 1 (2.25 mm)
 double-pointed needles

*Here is a cap pattern with a doubled ribbed cuff. Use the
hand chart from Mitten 6, or choose another mitten chart;
it's up to you. Use the top of crown chart on the facing page to
work on the colors needed for the last three rounds.*

Note that if you prefer double-pointed needles to circulars (as I do!) and own more than one set in the size needed, this is a great opportunity to work with 6 double-pointed needles—one for each pattern repeat and one as the working needle.

Gauge

8-st gauge (Child's, Adult's):
16 sts and 18 rnds = 2" over two-color St st worked in the rnd with larger needles
10-st gauge (Adult's):
20 sts and 22 rnds = 2" over two-color St st worked in the rnd with larger needles

Instructions

With smaller dpns, CO 120 (140, 160, 180, 200, 230) sts. Join, being careful not to twist sts. Beg K1, P1 ribbing, pm at end of first rnd. Cont K1, P1 ribbing for 1¼ (1½, 1¾, 2, 1¾, 2)". Purl 1 rnd.

Wrap next st, turn work, and push completed knitting through your needles. You'll be knitting in other direction now. Resume K1, P1 ribbing for an additional 1¼ (1½, 1¾, 2, 1¾, 2)".

Switch to larger dpns. Attach CC yarn(s) and knit from chart for appropriate size and gauge and chart appropriate for number of cast-on sts, beg at bottom right-hand corner. There will be 5 reps of patt around hat. Be sure to work "seam" sts and inside red lines if you need to. Cont until entire chart for matching size is complete, changing from circular needle to dpns when working on circular needle becomes awkward. There will be 40 sts when you have worked the final rnd from chart.

Crown (dec rnds): Work top of crown chart below, which shows how to work final 4 rnds of dec. Note that the decs are worked from the center of the cap, not the seam sts. If using a different hand chart, color the chart to match patt for your cap.

Using a Mitten Chart to Design a Cap

If you do a little arithmetic based on the size of the mitten charts and head sizes, a wonderful thing becomes apparent. If you use five repeats of the flat mitten chart, you get a cap that fits the size the mitten will fit.

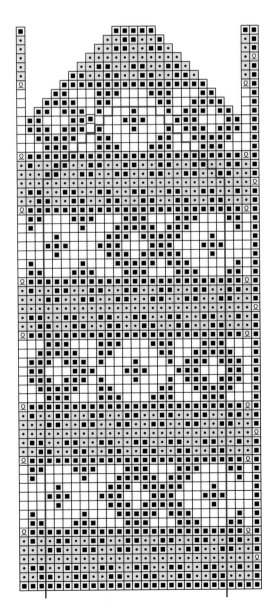

■ Green (MC)
□ Yellow (CC1)
⊡ Pink (CC2)
▣ sl st

For Mitten 6 chart,
CO 120 sts for Child's Medium
CO 140 sts for Child's Large

Top of Crown Chart

◺ ssk □ Green
◹ K2tpg ▥ Pink
◩ sl 1-K1-psso

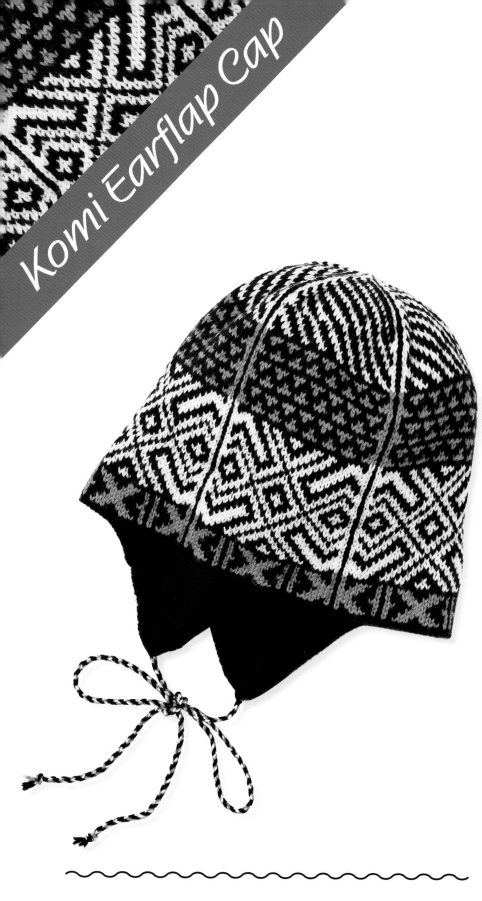

Komi Earflap Cap

Skill Level

Experienced ■■■■▶

Sizes

Six sizes are provided for two different gauges.
Child's Medium [CO 120 sts] (Child's Large [140 sts], Adult's Medium [160 sts], Adult's Large [CO 180 sts])—in gauge of 8 sts to 1"; Adult's Medium [CO 200 sts], Adult's Large [230 sts]—in gauge of 10 sts to 1")

Note that the sample cap pictured at left is for an Adult's Medium or an Adult's Large, with a cast on of 160 or 180 sts. When selecting a different chart, keep in mind that the CO for a cap needs to be 5 times the number of sts in the hand chart.

Finished circumference

Approx 15 (17½, 20, 22½, 20, 23)"

Yarn

Babygarn 2-ply from Nordic Fiber Arts (100% wool; 50 g; 191 yds) (**1**)
MC: 2 skeins in color Navy Blue
CC1: 1 skein in color Medium Blue
CC2: 1 skein in color White

Needles

For gauge of 8 sts to 1":
Size 2 (2.75 mm) circular needle (16" long)
Size 3 (3.25 mm) circular needle (16" long)
Set of 5 size 3 (3.25 mm) double-pointed needles
For gauge of 10 sts to 1":
Size 0 (2.0 mm) circular needle (16" long)
Size 1 (2.25 mm) circular needle (16" long), or size to obtain gauge
Set of 5 size 1 (2.25 mm) double-pointed needles

This cap pattern matches that of Mitten 29 on page 86. Generic instructions are provided so that you can adapt any mitten chart.

Gauge

8-st gauge (Child's):
 16 sts and 18 rows = 2" in two-color St st worked in the rnd on larger needles
10-st gauge (Adult's):
 20 sts and 22 rows = 2" in two-color St st worked in the rnd on larger needles

Instructions

With larger circular needle and MC, CO 120 (140, 160, 180, 200, 230) sts using knitted-on CO (page 13). Join, being careful not to twist.

Hem and Earflaps: Change to smaller circular needle and work in St st for 2". At beg of next rnd, pm and beg short rows, leaving the "dormant" earflap stitches on the circular needle as you proceed:
P11 (13, 15, 16, 18, 21), turn.
K29 (33, 37, 43, 48, 56), turn.
P29 (33, 37, 43, 48, 56), turn.
K28 (32, 36, 42, 47, 55), turn.
P27 (31, 35, 41, 46, 54), turn.

Cont in St st, working 1 less st each row until you have purled a row of 5 sts. Turn. K5.

Now reverse the process, picking up "dormant" earflap sts one at a time and working them along the edges:
P6, turn.
K7, turn.

Cont until you have worked a row of 29 (33, 37, 43, 48, 56) sts. One earflap complete.

For second earflap,
P40 (48, 56, 62, 68, 76), turn.
K29 (33, 37, 43, 48, 56), turn.

Cont to work second earflap to correspond with the first. Purl to end of round [11 (13, 15, 16, 18, 21) sts].

Body: Change to larger circular needle. Beg chart at round indicated for your size. When you have worked 2" of body pattern, pick up the hem as follows.

Picking up hem: With a double-pointed needle, pick up 1 stitch along the cast-on edge for every stitch cast on; knit each stitch with its corresponding live stitch, being careful to maintain the pattern of the body of the cap. It may be easier to pick up one stitch at a time, rather than picking up a needle full. This method joins the hem invisibly and in an absolutely straight line. (If you prefer, you may sew the hem when the cap is complete. Turn hem at purl bump.)

Cont in patt to crown. Switch to dpns when there are too few sts to support the circular needle.

Crown (decs rnds): Work the crown decs for Mitten 29 (or chart of your choice) until there are 40 sts total (8 sts per section). Then work the top of crown chart below, which shows how to work the final 4 rnds of the dec. Note that the decs are worked from the center of the cap, not the seam sts. If using a different hand chart, color the chart to match patt for your cap.

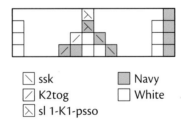

	ssk		Navy
	K2tog		White
	sl 1-K1-psso		

Break yarn, leaving an 8" tail. Thread tail through rem sts and fasten off. Make a 2-color lanyard braid (see below) for each earflap.

Lanyard Braid

This is the same technique many have learned at summer camp using plastic lacing. Using two colors is fun—if both strands of one color are on the same side, you get a diamond pattern, while if you have a light and dark on each side there will be a spiral.

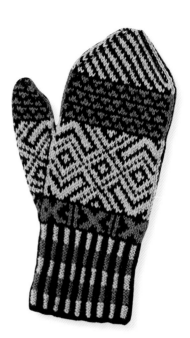

You also have the option of making the braid in a solid color. Lanyard braid uses four strands of yarn. I use a double thickness of yarn for each "strand."

1. Insert 4 equal lengths of yarn (about 50" long) through the end of the earflap—in this case two navy, one white, and one light blue. Even up the ends. Arrange the lengths of yarn into four double-thickness strands. Fan out the strands slightly. The strand farthest to the left is in position 1, positions 2 and 3 are in the middle, and position 4 is farthest to the right.

1 2 3 4

2. Start with the strand in position 4, bringing that strand to the left and behind the two center strands, then in front of strand 2, ending at position 3. (The strand that started out in position 4 is now in position 3, and the former strand 3 is now in position 4.)

1 2 3 4

3. Now take the strand in position 1 and bring it behind the two center strands, then in front of strand 3, ending in position 2.

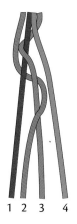

1 2 3 4

Repeat steps 2 and 3 until you have the length you desire.

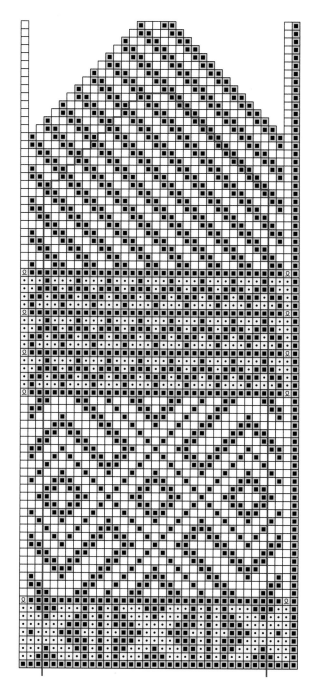

☒ Navy blue (MC)
⊡ Medium blue (CC1)
☐ White (CC2)
☒ sl st

For Mitten 29 chart,
CO 160 sts for Adult's Medium
CO 180 sts for Adult's Large

Abbreviations

approx	approximately
beg	begin(ning)
CC	contrasting color
cm	centimeter
CO	cast on
cont	continue(ing)(s)
dec(s)	decrease(ing)(s)
dpn(s)	double-pointed needle(s)
g	grams
inc(s)	increase(ing)(s)
K	knit
K2tog	knit 2 stitches together—1 stitch decreased
m	meter(s)
MC	main color
mm	millimeter(s)
M1	make 1 stitch
M1R	make 1 reverse
oz	ounce(s)
P	purl
P2tog	purl 2 stitches together—1 stitch decreased
psso	pass slipped stitch over
rem	remain(ing)
rnd(s)	round(s)
sk	skip
sl	slip
sl1-k1-psso	slip 1 stitch as if to knit, knit 1 stitch, then pass slipped stitch over the knit stitch—1 stitch decreased
ssk	slip 2 stitches, 1 at a time as if to knit, to right needle, then insert left needle from left to right into front loops and knit 2 stitches together—1 stitch decreased
st(s)	stitch(es)
St st	stockinette stitch: in the round, knit every round
tog	together

Bibliography

Harlow, Eve (Ed). *The Art of Knitting*. London & Glasgow: William Collins and Sons, 1977.

Kalashnikova, N. M. *National Costumes of the Soviet People*. Moscow: Planeta, 1990.

Klimova, Galina Nikolaevna. *Uzornoe Viazanie Komi (Knitted Patterns of the Komi)*. Syktyvkar, Komi Republic, Russia: Komi Book Publishing House, 1978.

Klimova, Galina Nikolaevna. *Tekstil'nyi ornament (Komi Textile Ornamentation)*. Syktyar: Komi Krizhnoe izd-vo, 1984.

Rutt, Richard. *A History of Hand Knitting*. Loveland, CO: Interweave Press, 2003.

Starmore, Alice. *Alice Starmore's Book of Fair Isle Knitting*. Newton, CT: Taunton Press, 1988.

Starmore, Alice. *Charts for Colour Knitting*. Gress, UK: The Windfall Press, 1992.

Swansen, Meg. *Wool Gathering #55*. Pittsville, WI: School House Press, 1996.

Upitis, Lizbeth. *Latvian Mittens: Traditional Designs & Techniques*. Pittsville, WI: School House Press, 1997.

Resources

Refer to the following websites for information on the yarns used in this book.

Brown Sheep Company, Inc.
http://brownsheep.com
Nature Spun Fingering
Nature Spun Sport

Dale of Norway
www.dale.no
Heilo

Harrisville Designs
www.harrisville.com
New England Shetland

Nordic Fiber Arts
www.nordicfiberarts.com
Babygarn 2-ply
Finullgarn 2-ply

Schoolhouse Press
www.schoolhousepress.com
*Helmi Vuorelma Oy Satakieli
2-ply Finnish Yarn*

The Wooly West
www.woolywest.com
*Helmi Vuorelma Oy Satakieli
2-ply Finnish Yarn*

About the Author

Charlene Schurch, a knitter since before she could read, is fascinated with the historical and technical aspects of knitting. Her work includes six previous books, most of which contain small projects. These small projects are compatible with her warm-weather lifestyle, along with her short attention span. In addition to knitting, she is an avid spinner and dyer. She teaches on the national level for guilds, folk schools, and fiber festivals. Most recently she has written *Sensational Knitted Socks* (2005), *More Sensational Knitted Socks* (2007), and *The Little Box of Socks* (2008), all from Martingale & Company.

See more online! Check out Charlene's other books at www.martingale-pub.com